IMAGES
of America

THAIS IN
LOS ANGELES

June 22, 2012

Dear Lisa,

Thank you for your
support of Thai CDC and
our community over the
years. helping advance
our social and material
goals.

Welcome to Thai Town!

Chancee

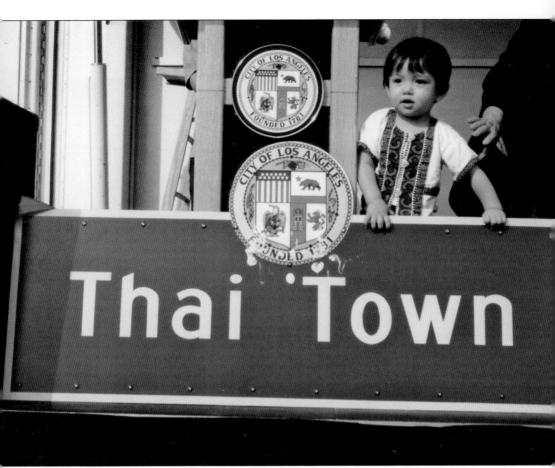

Emiliano Martorell, a Thai American, was eager to investigate the new Thai Town road sign at the ribbon cutting ceremony for the designation of Thai Town in January 2000. (Courtesy of Chanchanit Martorell.)

IMAGES
of America

THAIS IN LOS ANGELES

Chanchanit Martorell and
Beatrice "Tippe" Morlan

ARCADIA
PUBLISHING

Published by Arcadia Publishing
Charleston, South Carolina

Printed in the United States of America

Library of Congress Control Number: 2010934826

For all general information, please contact Arcadia Publishing:
Telephone 843-853-2070
Fax 843-853-0044
E-mail sales@arcadiapublishing.com
For customer service and orders:
Toll-Free 1-888-313-2665

Visit us on the Internet at www.arcadiapublishing.com

CONTENTS

ACKNOWLEDGMENTS

We express deep gratitude to Thai consul general Damrong Kraikruan for his enthusiastic and unwavering support of our project. When asked, he did not hesitate to contribute to our foreword.

While most of the photographs are courtesy of the Thai Community Development Center, we are grateful to the individuals who were willing to share their personal and family history with us. They include our elder statesman, Aroon Seeboonruang, whom we affectionately call "Pa Aroon," and his cousin, Pattarin Seeboonruang. Having been here since the beginning of the arrival of Thais over 45 years ago, they provide a pioneer's perspective on Los Angeles. We also appreciate the willingness and eagerness of the younger generation of Thais to contribute to the book. They include Wanda Pathomrit, Panida Rzonca, Nixon Vayupakparnonde, Tina Vacharkulksemsuk, Jade and Cynthia Dhachayangkul, Anne and Alisa Chatprapachai, and Rosalyn Patamakanthin. Unless otherwise noted, all images in chapter five appear courtesy of Monk Phra Boonlerm.

Our heartfelt gratitude goes to the Wat Thai of Los Angeles for continuing to serve as a very important spiritual and cultural resource for the community. The abundance of photographs provided to us by longtime resident monk and public relations representative for the temple, Phra Boonlerm, clearly illustrates the temple's deep roots and significant role in shaping the Los Angeles Thai community.

We owe a great deal of thanks to our community journalist, Panupong Rugtae-Ngam, and photographers Jump and Nuno, who were willing to share with us their professional photographs of key events, institutions, and people in our community. We were so fortunate that the timing of our endeavor happened to coincide with the completion of a major photographic exhibition of the Thai Community of Los Angeles by Jump, sponsored by the Royal Thai Consulate, allowing us to use some of these photographs.

We would also like to thank Pashree Sripipat for a photograph of her business, and Teresa Chung, Suvakon Kanchana, and Anne Muangmongkol for the Rotary Club of Thai Town photographs.

The strength of our community rests on our level of civic engagement. We are grateful to Gorpat Henry Chareon for his historic photograph as the first elected official in this country of Thai descent, and Officer Pete Phermsangngam, who is the face of the LAPD recruitment photograph.

And lastly, we thank Thai CDC's community planner, Alexander Holsheimer, who never declined to provide additional technical support on the scanning and adjustment of the photographs.

FOREWORD

I want to applaud the Thai Community Development Center (Thai CDC) for taking the initiative to have a book published on the Thai community in the United States. It is a highly commendable initiative. We all have our own history. Knowing our own history would surely help us understand ourselves better. We know who we are, what we have gone through, and what lessons we have learned. We know what we can be proud of in our heritage. This is very important for every community and every country. People who don't know history could never be called "educated," because they risk repeating mistakes and cannot move forward.

Since the birth of the Thai community in the United States, we have not seen any serious attempt to write the history of our community. Thai CDC's efforts in collaborating with Arcadia Publishing represent the first ever attempt of this kind. This is a great contribution on the part of Thai CDC. And the timing of this project could never be better. The very first generation of Thais arrived in the United States in the 1960s. These first generations are now in their late 60s or 70s, some even older. If we don't start to collect historical evidence and seek interviews with these people, we will soon lose those opportunities. People's memories would surely fade with age. Or even worse, what happens if those people are not there anymore to tell us their stories?

I am absolutely sure that we in the Thai community will be proud of this initiative and anxiously await the final product of this endeavor. Our second and third generations would also be proud of the many stories of their parents, grandparents, or even their great-grandparents featured in this book. And I am sure that they would be reminded of the dreams and hopes of their forefathers and join hands to make those dreams and hopes come true.

—Damrong Kraikruan
Consul General of Thailand, Los Angeles
August 3, 2010

INTRODUCTION

Although Thai food has become one of Los Angeles's most popular cuisines—from an overnight sensation to an established local favorite within a few years—not much more is known about the Thai American experience in what is now the largest Thai enclave outside of Thailand anywhere in the world.

This photograph narrative provides a visual synopsis of the historic first steps taken by these most recent newcomers to America's western portal of Los Angeles. Although Thai immigration history in the United States is relatively brief compared to other Asian ethnic immigrants, the Thai community already has left a distinctive mark on the face of the Asian Pacific American community and American society. Nonetheless, Thai Americans' contributions to the social, cultural, and economic fiber of our global city are neither documented nor fully acknowledged, leaving Thais to struggle in the shadows as an often overlooked population.

This obscurity does not mean that Thai immigrants strive, struggle, or achieve any less than any other immigrants. To the contrary, Thais face all of the same language, social, cultural, and economic barriers as other immigrant communities, but their struggles go unnoticed until extreme circumstances bring individual cases to light in a sensational manner. Many have heard of the El Monte slave shop, where Thais were held in captivity as garment workers; few, however, know what it is like for ordinary Thais to build lives in America because that is not deemed newsworthy.

The designation of Thai Town was a major milestone for the Thai community. It gave Thais a sense of belonging while increasing their visibility. As a cultural destination, Thai Town offers Thais and visitors a truly authentic Thai cultural experience. It also hosts the largest Thai festivals and celebrations in the United States with native costumes, unique arts and handicrafts, and popular demonstrations of Muay Thai.

Undoubtedly, the 2010 census will show dramatic growth in the Thai community in the past decade. This growth is not just in numbers, but in the overall complexity of our community as new institutions and enterprises are built to integrate Thais into the mainstream, culturally and economically. This growth also means that Los Angeles will always have a vibrant, active, and visible Thai community, one known for contributing far more than its cuisine to our society.

—Chanchanit Martorell

One

ARRIVAL IN LOS ANGELES

Immigrants from Thailand are significantly adding to the ethnic and cultural diversity of the United States. Although Thais constitute only a small fraction (an estimated 80,000 in Southern California) of the large Asian immigrant group, their increase in the last 45 years has been significant. Newcomers redistribute themselves throughout the United States, giving rise to notable regional concentrations. More than half of all the Thais present in the United States are unofficially estimated to be living in Southern California, which at the same time acts as an attraction pole for half of the new immigrants.

Thais' fast-growing influx and their regional concentration in the Los Angeles area is a recent phenomenon that has yet to be thoroughly documented. Thai migration has passed through three stages of the immigration pattern. The first stage, pioneer migration, coincided with the two postwar decades, when only a handful of educated, middle-class Thais immigrated each year. The second stage, group migration, was ushered in by the change in American immigration laws; it was marked by a slow but steady increase in numbers and by a gradual change in the composition of the migrant flow. At the present time, the third stage, or mass migration, is occurring.

A higher proportion of immigrants were women during the early part of the mass migration stage. But in the 21st century, men and the occupational composition of Thai immigrants is evidenced and characterized by an increase in the proportion of unskilled workers and by a decline in the average level of English proficiency and educational attainment at the time of arrival.

Although the Thai immigrants share some similarities with other Asian immigrant groups, the Thais differ in their demographic and occupational characteristics, in their initial motivations for migration, and in their distribution within the Los Angeles area. The attraction of better opportunities and the desire to join relatives already established here were the primary reasons for immigrating to the United States. Therefore, Thais are considered economic immigrants. Unlike other Southeast Asians, Thais are not political refugees fleeing persecution or civil strife back home.

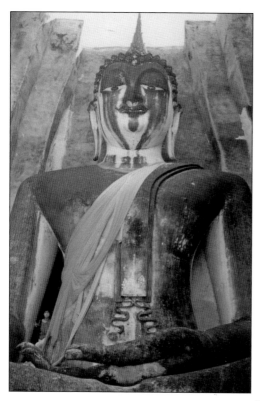

Buddhism and Buddhists play a key role in Thai culture. Nearly 95 percent of the home country population is Buddhist. Thailand is known for its ancient Buddha statues, including this Buddha image carved into a rock in the ancient city of Sukothai, Thailand. Chancee Martorell took this photograph during her study abroad in Thailand at Chiang Mai University, the first institute of higher education in Northern Thailand, in 1988.

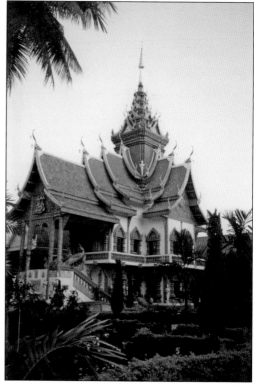

This is a *wat*, or Thai Buddhist temple, built in traditional Lanna Thai architecture, located in the city of Chiang Mai in Northern Thailand. Chiang Mai is the second largest city in Thailand next to Bangkok.

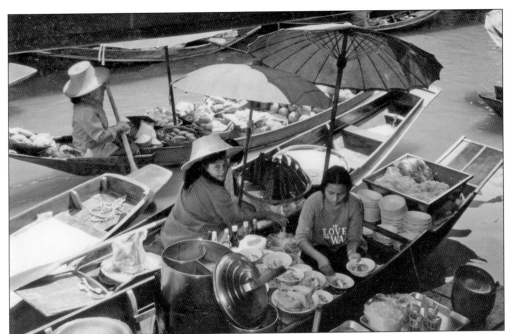

This photograph depicts the famous floating market just outside of Bangkok in 1988. Floating markets have played an important role in Thailand's economy throughout its history as a place where people gather to buy, sell, and trade a variety of foods, flowers, and many other local products. (Photograph by Chanchanit Martorell.)

Elephants are the most cherished animals in Thailand as a symbol of power, hard work, and royalty. Traditionally, the elephant is an animal of the king and queen and used by the royal family to ride to war.

HIS TROPHIES ARE MANY

AROON SEEBOONRUANG

The outline of Ancient Thailand, on the map of Asia has been compared to a crouching animal. Its head and forefeet are plunged into Indochina and its hunched back rests against Burma and its long tail forms part of the Malaysian-Peninsula.

And because of AROON SEEBOONRUANG, Thailand has leaped into International prominence and in more ways than one. For he is not only a TENNIS CHAMPION but he has played an important part in the business and educational world, as well.

Aroon's warm personality wins him lasting friends all over the world - and little do the tourists realize, when visiting his shop called, "THAILAND GIFTS" at the Ala Moana Shopping Center in Honolulu, that it was he who took the men's "45" singles 1967 Tennis Title, when he recently tossed the 1966 Titleholder, Japan's Matsu Okumoto, in the 17th Annual Dillingham Open Tennis Tournament.

Incidentally, in his "spare" (?) time, he is Sales Representative for Universal Motors, too, and previously has been a language Instructor at the University of Hawaii's Peace Corp Training Center.

This newspaper clipping features the well-respected Thai elder in Los Angeles and former world famous tennis champion, Aroon Seeboonruang, whom everyone calls Pa Aroon. Upon arriving in Hawaii where he first entered the United States in the late 1960s, he coached tennis for the University of Hawaii.

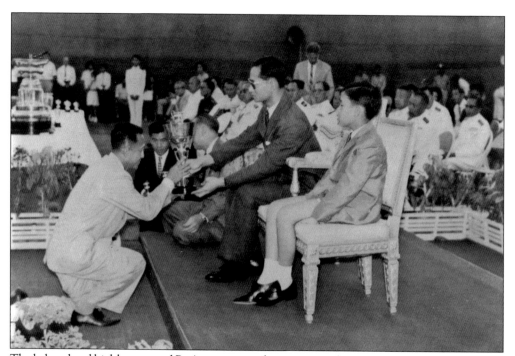

The beloved and highly esteemed Pa Aroon received an auspicious honor from the King of Thailand, Bhumibol Adulyadej, in Bangkok, for being the best tennis player in the nation in the 1960s. Pa Aroon is currently president of the Thai Senior Citizen Club of Los Angeles and founder of the Wat Thai of Los Angeles, the Thai temple. (Courtesy of Aroon Seeboonruang.)

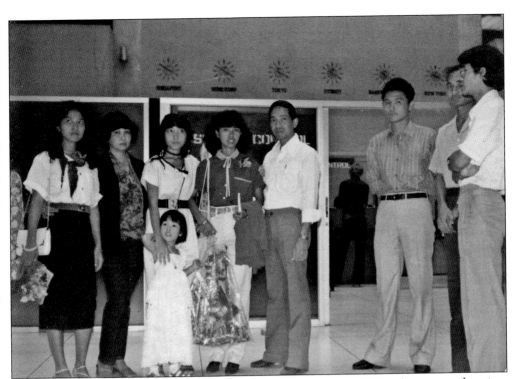

In the 1980s, many Thais immigrated to the United States to receive an American education. Chotiros Watjanarut left Thailand in January 1981 to attend Brigham Young University-Hawaii. This photograph is of her father, Choochad Watjanarut, and other family members seeing her off at Bangkok International Airport. (Courtesy of Chotiros Morlan.)

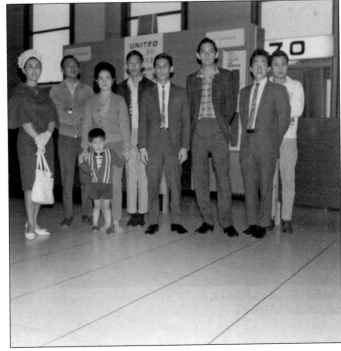

Family and friends of Pattarin Seeboonruang, cousin to Aroon Seeboonruang, came to bid farewell to her and her husband at the Don Muang Airport in Bangkok, as they immigrate to Los Angeles to seek educational opportunities in the late 1960s. (Courtesy of Pattarin Seeboonruang.)

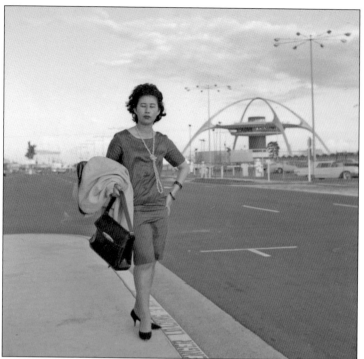

Pattarin Seeboonruang strikes a pose with the iconic Los Angeles Airport restaurant in the background after she lands at the airport and begins a new life in the City of Angels.

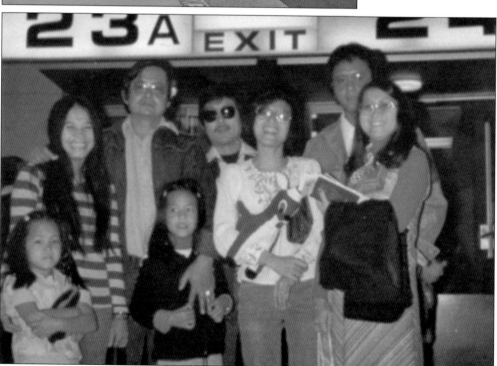

Kusuma Kamachuntree arrived from Thailand at Los Angeles International Airport in the mid-1970s. She is pictured at the far right and her husband, Narong Kamachuntree, is pictured in the center along with family members Somnuck Hirunpidok, Chancee, Visalaya, Somchua, Sukumal, and a family friend.

Two

HELLO TO HOLLYWOOD

The Thai community in Southern California is the largest in the United States and the largest outside of Thailand. Yet it is barely noticeable in the midst of the more numerous and more conspicuous Chinese, Japanese, Korean, and Filipino communities. The spatial pattern of Thai settlement is characterized by a few diffuse clusters, the densest being in Hollywood, where a 2-mile stretch along Hollywood Boulevard, with a branch north toward the Wat Thai (Thai Temple) in North Hollywood, displays the largest concentration and variety of Thai businesses.

Smaller clusters appear in the Long Beach corridor, encompassing communities such as Lynwood, Cerritos, and Bellflower. A significant number of Thais are also concentrated in Glendale and in nearby parts of the San Fernando Valley, including the Los Angeles city neighborhoods of Van Nuys, Panorama City, Sun Valley, Arleta, and Pacoima. With the proliferation of Thai-owned businesses and shops, these areas have become Thai ethnic enclaves for newly arrived Thai immigrants, the majority of whom are poor and speak no English. Yet Thai immigrants contribute much to each of these areas' economies. Thai businesses have revitalized depressed neighborhoods, and Thai workers have become an integral part of the local workforce.

The universal appeal of Hollywood originally attracted Thais to this entertainment capital, known in Thailand as it is throughout the world. Practically every Thai, even in the most remote villages, knows of Hollywood as the place of fame and fortune. The temperate climate of Southern California and the familiarity of a place popularized in the media back home made it easier for Thais to put a stake in Hollywood.

A deliveryman took this picture of Wanda Pathomrit, a local Thai community activist, in 1996 as they were passing out fliers for her mother's restaurants around the Hollywood neighborhood. Wanda's parents used to own a restaurant on Sunset and Vine after coming to America with only one suitcase of hope. (Courtesy of Wanda Pathomrit.)

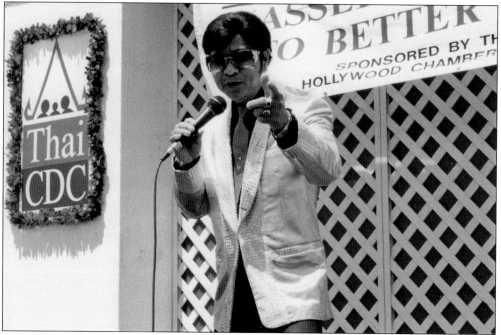

What does one get when Hollywood and the Thai community meet? Our very own icon and legend, Thai Elvis! Thai Elvis has been a fixture in Los Angeles for over 30 years, performing most often at the equally famous Palms Thai restaurant in Hollywood.

16

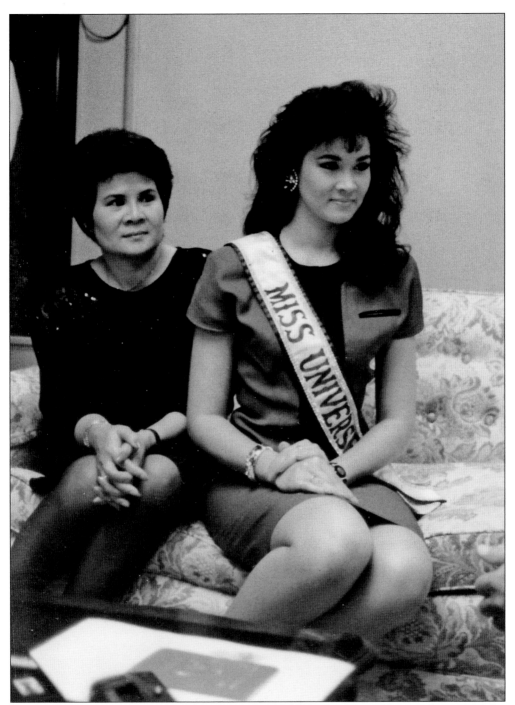

The newly crowned Miss Universe, Porntip "Bui" Nakhirankanok, and her mother visited the Royal Thai Consulate General in 1988. She is the second Thai woman in history to win the crown. Born in Thailand, Bui grew up in Los Angeles and became the pride of the Thai American community, rocketing to celebrity status upon winning Miss Universe.

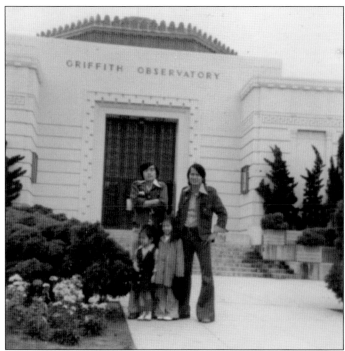

Sombat Hirunpidok with his nieces, Chancee and Visalaya, and his nephew, Nares Teeravate, are posing in front of the historic Griffith Park Observatory in the mid-1970s.

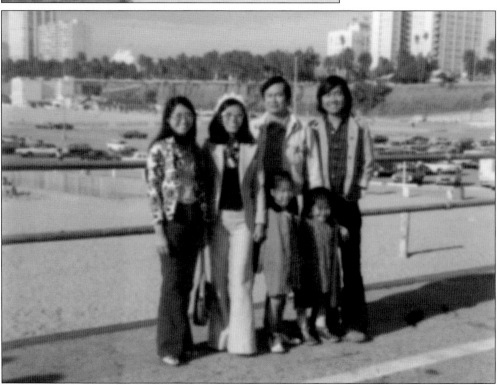

The Hirunpidok family including Somnek, Chancee, Visalaya, and their father's side of the family, Aunt Kusuma, Aunt Sukumal, and cousin Nares Teeravate, are on the famous Santa Monica Pier in the mid-1970s.

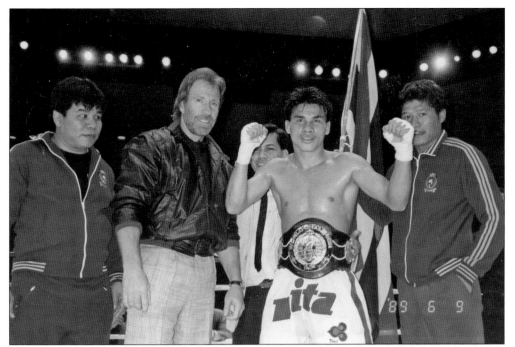

This Muay Thai boxer won his championship belt in a match and was offered congratulations by Hollywood action star Chuck Norris. Muay Thai boxing is a form of Thai martial arts that has become a famous and popular activity in the United States.

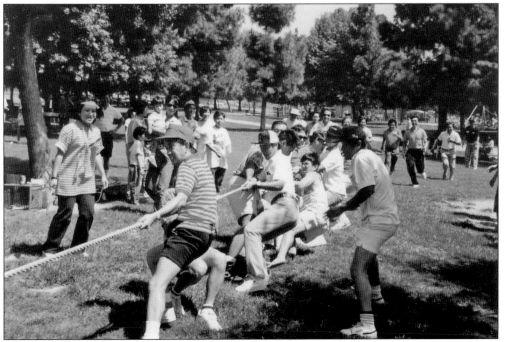

Alumni and students of Thammasat and Chulalongkorn Universities and their family members played tug-of-war at a picnic at Whittier Narrows Recreation Area in the 1980s. Such get-togethers developed an early sense of community and camaraderie. (Courtesy of the Suthai Musikawong.)

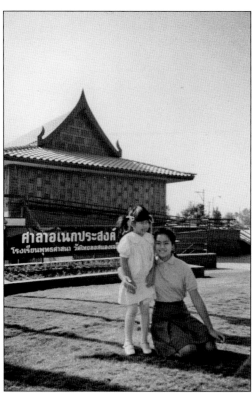

A young Panida and Sudarat Musikawong are at the Wat Thai of Los Angeles School. Religion is central to the Thai culture, and having a *wat*, or a temple, to worship at was a great draw for immigrants who decided to come to Los Angeles. (Courtesy of Suthai Musikawong.)

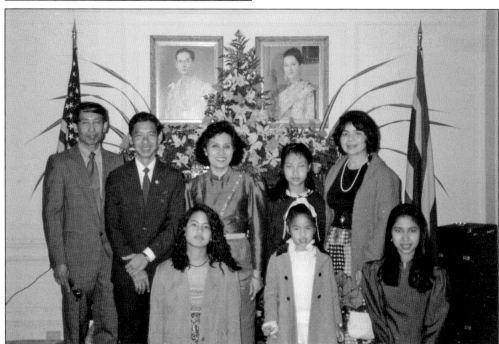

The Musikawong family is pictured with the Thai consul general, second from the left, and his family at the residence of the consul general in Hancock Park, Los Angeles, in the late 1980s. (Courtesy of Suthai Musikawong.)

The mother and father of Nixon Vayupakparnonde, a prominent member of the Thai Association of Southern California and a local community activist, are pictured in downtown Los Angeles in the 1960s. (Courtesy of Nixon Vayupakparnonde.)

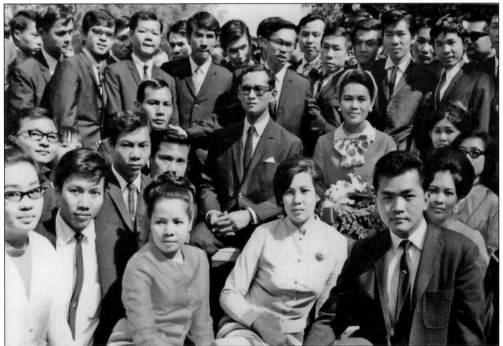

Nixon's father, with his friends and colleagues, is pictured with the king and queen of Thailand in Beverly Hills while they were attending university in Los Angeles. (Courtesy of Nixon Vayupakparnonde.)

Wanda Pathomrit's mother was living and working in Los Angeles as an undocumented immigrant. Her parents intended to work and return to Thailand, as did many other Thai immigrants, and never thought they would have a child in America. Her mother did not know she was having a baby until six months into the pregnancy, and on November 20, 1986, she gave birth to a healthy baby girl. (Courtesy of Wanda Pathomrit.)

Pichet and Somporn Vacharkulksemsuk are pictured here at Somporn's 60th birthday celebration in January 2008. They both arrived in California in 1972 and lived in Los Angeles. Pichet went to Los Angeles City College where he earned a bachelor's degree in business administration. (Courtesy of Tina Vacharkulksemsuk.)

Tanya Vacharkulksemsuk and Tortugal Sawad-xuto are pictured here also at Somporn's 60th birthday party. Tortugal came to Los Angeles in 2005 with the intent to obtain a bachelor's degree, but instead he moved to New York to seek better job opportunities. (Courtesy of Tina Vacharkulksemsuk.)

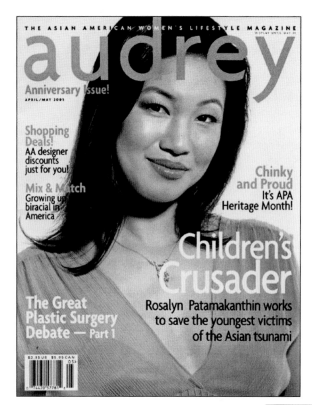

Thai American attorney Rosalyn Patamakanthin was featured on the front cover of the April/May 2005 issue of *Audrey Magazine*, the Asian American Women and Lifestyle Magazine, for her efforts to save the youngest Thai victims of the Asian Tsunami. (Courtesy of Rosalyn Patamakanthin.)

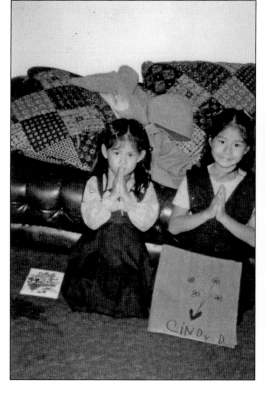

Jade Dhatchayangkul and her sister, Cynthia, are performing the *wai*, the Thai sign of greeting and respect. Jade and Cynthia are both half Thai and half Mexican, mirroring the diversity of the Los Angeles population. Jade graduated from California State University Los Angeles with a masters of business administration and currently works for NASA's Jet Propulsion Laboratory. (Courtesy of Jade Dhatchayangkul.)

Three

A MATTER OF SURVIVAL
STRUGGLING FOR A VOICE AND RIGHTS

A key issue confronting newly arrived Thai immigrants has been their economic struggle for survival. Thai immigrants have faced enormous language and cultural barriers and therefore often remain isolated with no resources to meet their health and welfare needs. With limited English language skills, many in the Thai community have been unable to access public and private services available to the general public. Thai immigrants may resist making cultural adjustments in their effort to cope with the changes in their environment, therefore contributing to high-risk behaviors. Without the safety net of social support, which they enjoyed in their native country, these immigrants have had to overcome great difficulties in acculturating, which have contributed to their further isolation. Unaware of their legal rights, they are often susceptible to the most severe and egregious forms of exploitation.

In fact, on August 2, 1995, the world woke up to the most shocking case of all involving over six dozen Thai nationals who were discovered working in conditions of slavery in a makeshift garment factory just east of Los Angeles in El Monte, California. The case drew international attention as the first case of modern slavery in the United States since the abolishment of slavery in 1860.

The community-based organization, Thai Community Development Center (Thai CDC), participated with a multi-government agency task force in a predawn raid to liberate the Thai men and women from their enslavement. However, the famed El Monte Thai Slavery Case was just the tip of the iceberg as Thai CDC went on to work on a half dozen more cases in the next 15 years involving more than 400 Thai nationals trafficked into the United States for the purpose of sexual slavery and forced domestic, construction, and agricultural labor.

Thai CDC intervention and the resiliency of the workers' spirits allowed them to move on with their lives, reunite with families, and celebrate life. These survivors also declared that their years of imprisonment would not be the end of their story. Many of these workers became activists themselves. With the guidance of Thai CDC and other organizations and their own consciences, these workers fought modern-day slavery. They joined labor protests, rallies for workers' rights, and other political actions, crossing ethnic and cultural lines.

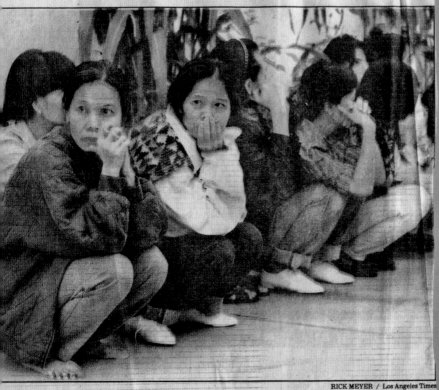

The historic *Los Angeles Times* article appeared on August 3, 1995, the day after the multi-governmental agency raid on a clandestine, makeshift garment factory in El Monte. Seventy-two Thai nationals were discovered working in conditions of slavery for as long as seven years, sewing clothes for major manufacturers and retailers.

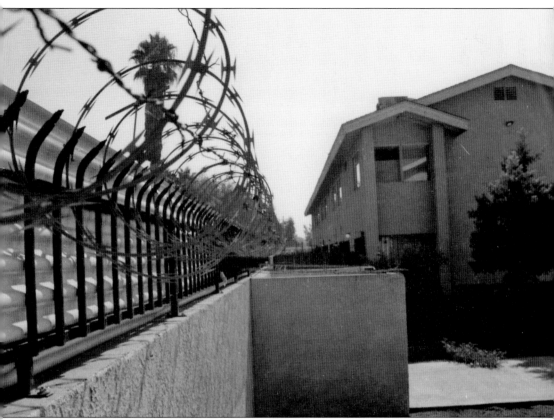

As the first case of modern-day slavery in the United States since slavery was abolished, the El Monte Thai Slavery Case would go on to serve as a landmark case in U.S. labor history, reforming the garment industry and starting an anti–human trafficking and slavery movement. This 1995 image shows the razor barbed wire surrounding the apartment complex used to keep the El Monte Thai workers from escaping.

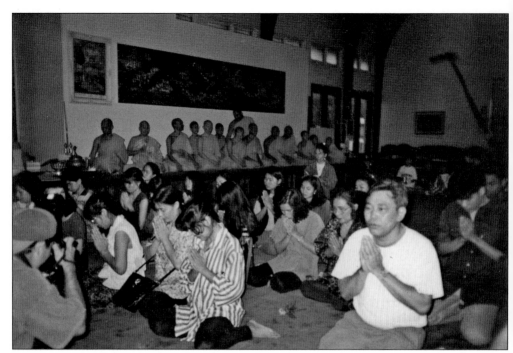

On August 11, 1995, soon after Thai CDC and its allies won the release of the El Monte Thai workers from their second form of captivity in immigration detention, Thai CDC brought them to the Wat Thai of Los Angeles to receive the spiritual nourishment they were lacking throughout their enslavement for as long as seven years. The El Monte Thai workers celebrated their freedom at the Griffith Park Observatory above Hollywood with Chancee Martorell in August 1995.

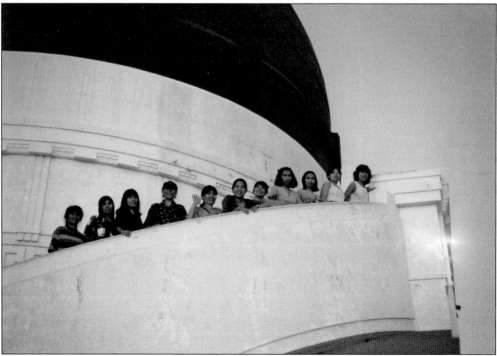

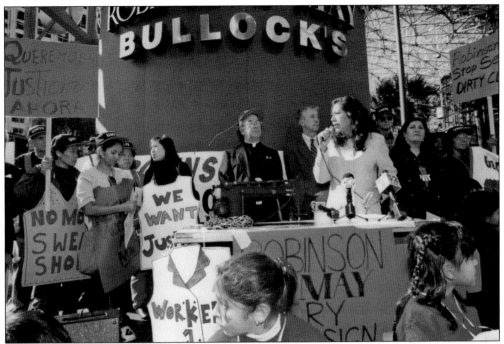

Soon after their liberation, the El Monte workers joined the Retailer Accountability Campaign. At a rally to protest Robinsons-May for profiting off of sweatshop labor, then–state senator Hilda Solis came out to support the El Monte Thai workers and other garment workers, Thai CDC, the union, UNITE, and other labor rights activists in the demand for retailer accountability. In 2008, Pres. Barack Obama appointed Hilda Solis as his secretary of labor.

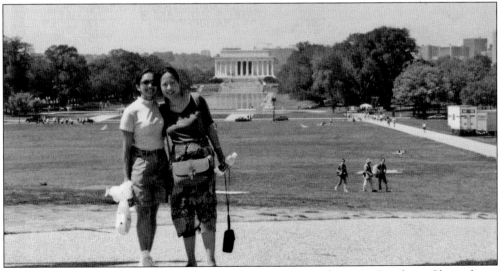

Former El Monte Thai Slavery Case survivor, spokesperson, and activist, Rotchana Cheunchujit, with Thai CDC executive director Chancee Martorell, are pictured in front of the Lincoln Memorial. They traveled to Washington, D.C., to speak about Rotchana's traumatic experience as a formerly enslaved garment worker and what must be done to end human trafficking at an AFL-CIO labor union–sponsored Working Women's Conference with special guest Vice Pres. Al Gore in August 1997.

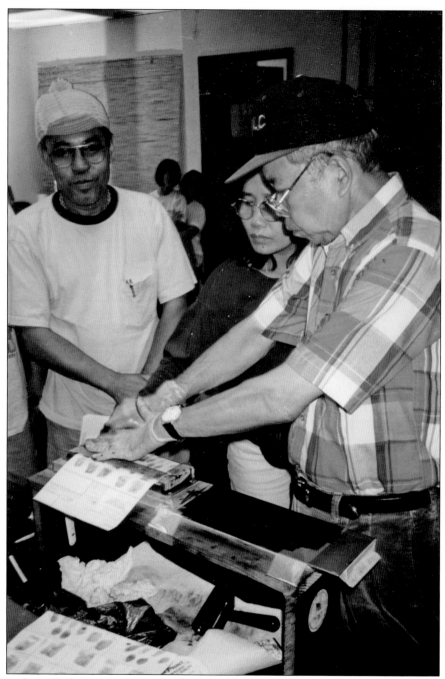

Thai workers Wuthipong and Jamaree from the El Monte Thai Slavery Case are fingerprinted by the U.S. Immigration and Naturalization Service for their "S" visas, which provided them relief from deportation after their case was prosecuted successfully in 1996. To deport them would send the wrong message that any worker coming forward to report their abuses would be summarily deported. This form of deportation relief would later become known as the "T" visas, now available for trafficked victims, and enacted into law by Congress in 2000 as part of the Trafficking Victims Protection Act (TVPA).

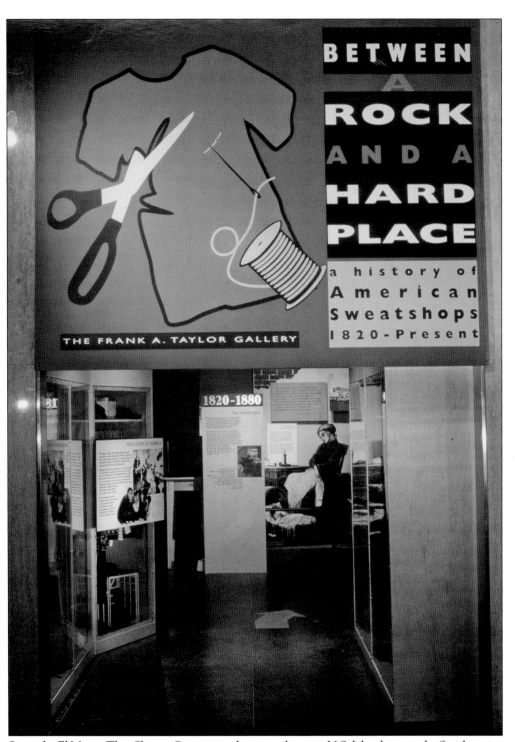

Since the El Monte Thai Slavery Case was such a pivotal case in U.S. labor history, the Smithsonian Institution in Washington, D.C., created an exhibit on American sweatshops from 1820 to the present. The 1999 exhibit included a large section on the El Monte case.

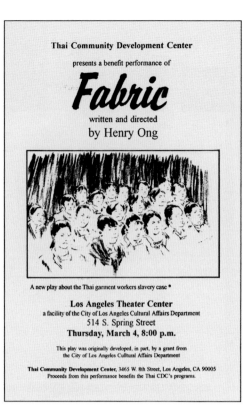

Thai Community Development Center

presents a benefit performance of

Fabric

written and directed
by Henry Ong

A new play about the Thai garment workers slavery case *

Los Angeles Theater Center
a facility of the City of Los Angeles Cultural Affairs Department
514 S. Spring Street
Thursday, March 4, 8:00 p.m.

This play was originally developed, in part, by a grant from
the City of Los Angeles Cultural Affairs Department

Thai Community Development Center, 3465 W. 8th Street, Los Angeles, CA 90005
Proceeds from this performance benefits the Thai CDC's programs.

This program illustrates the theatrical workshop performance of *Fabric*, written by the award-winning local playwright, Henry Ong, based on the landmark El Monte Thai Slavery Case. The play was presented by the Thai Community Development Center as a benefit on March 4, 1999. On the program is a sketch by a court artist of the Thai defendants in the criminal prosecution proceedings in the U.S. District Court for the Central District of California.

In 1999, the actors playing real-life characters from the El Monte Thai Slavery Case in the play *Fabric* included Jennifer Paz as the worker and Rotchana Cheunchujit and Diane Kobayashi as the evil Auntie Sunee.

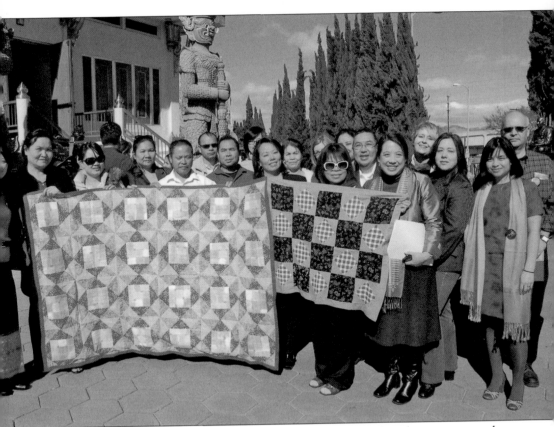

A press conference was held on February 10, 2010, at the Wat Thai of Los Angeles to announce the world premiere of *Fabric* in commemoration of the 15th anniversary of the El Monte Thai Slavery Case. The featured quilts were created by the survivors weaving their stories of despair, triumph, and resiliency as a part of the Thai Community Development Center's Adopt a Quilt Project.

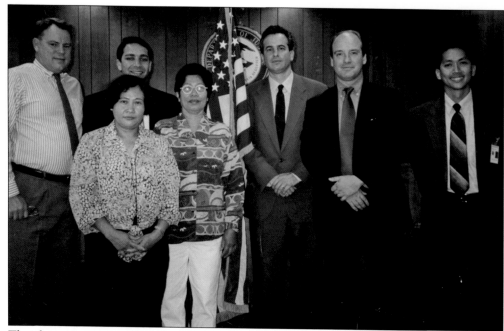

Thai domestic workers Thonglim Kamphiranon and Somkhid Yindiphot are flanked by the U.S. authorities who worked on their slavery case with the Thai CDC. They include Immigration and Naturalization Service special agent Philip Bonner, assistant U.S. attorneys Arif Alikhan and Jack Weiss, an agent from the Federal Bureau of Investigation, and the Thai court interpreter in Los Angeles in 2000.

NEWS RELEASE

For Immediate Distribution

October 27, 1998

NORA M. MANELLA
United States Attorney
Central District of California

Thom Mrozek, Public Affairs Officer
(213) 894-6947
thom.mrozek@justice.usdoj.gov

WOODLAND HILLS WOMAN INDICTED FOR HOLDING

FOUR ILLEGAL ALIENS AS INVOLUNTARY SERVANTS

A federal grand jury today returned a superseding indictment that charges a Woodland Hills woman with four counts of involuntary servitude for holding four illegal immigrants against their will, United States Attorney Nora M. Manella announced.

Supawan Veerapol, 52, a Thai national, was previously charged with harboring two Thai women at her home. Today's eight-count indictment adds two counts of harboring and adds the four counts of involuntary servitude.

The indictment stems from an arrest and search of the defendant's home on March 25. In court documents related to Veerapol's arrest and a search of her residence, the victims in the case said they were forced to work exceedingly long hours in oppressive working conditions and that Veerapol threatened harm to them or their families if they attempted to leave Veerapol's residence. The women claimed that the defendant censored their mail and prevented them from attending religious services. Veerapol also allegedly confiscated their passports and denied the women medical treatment, according to their statements to authorities.

This is the press release sent out by the U.S. Attorney's office on the indictment of the Thai socialite, Supawan Veerapol, who enslaved Thai domestic workers. These workers escaped to seek help from Thai CDC in 1998. The issue caused an uproar by upsetting the Thai social hierarchy system that Thai social elites attempt to perpetuate within the United States.

34

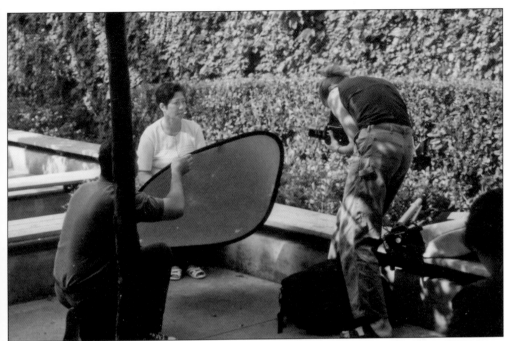

Thai domestic worker Somkhid Yindiphot is seen being prepared by the crew of Geraldo Rivera's *Dateline NBC* show for an interview in Thai CDC's Halifax Apartments courtyard in Los Angeles regarding their slavery case.

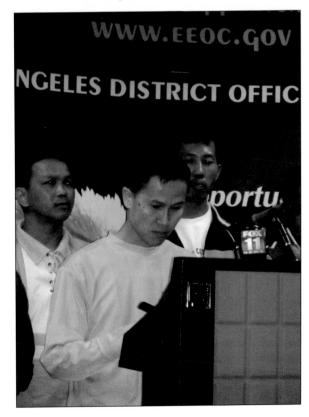

In January 2006, Sathaporn Pornsrisirisak speaks on behalf of a group of fellow Thai welders from another Thai CDC trafficking case at the Equal Employment Opportunity Commission press conference after winning over $1 million in settlement against Trans Bay Steel Corporation.

This is the "housing" provided to trafficked Thai farmworkers in Hawaii by Global Horizons before they escaped to seek help from Thai CDC (image *c.* 2003). (Courtesy of a Thai farm worker.)

Four

CREATION OF A THAI MIDDLE CLASS

Small businesses have historically played an important role in the development of immigrant Asian communities, including the Thai community. Not unlike other Asians, Thai immigrants experience a high rate of entrepreneurship and self-employment. Depressed wages as low-salaried workers and lack of access to mainstream jobs force many Thais into ethnic entrepreneurship, which is an important cornerstone of Asian economic activity.

Today small businesses remain an important alternative to low-wage employment in the informal economy as Thais continue to lack English proficiency and transferable skills, and suffer underemployment. Moreover, the belief that self-employment is a superior alternative to low-wage work as a strategy for upward mobility has historical salience for both immigrants and native-born populations alike.

The nature of small business formation in the Thai community includes reliance on low capital, ethnic networks, and cheap labor, which limit the size and profitability of the businesses. With the proliferation of Thai-owned businesses in Los Angeles over the past 45 years—particularly Thai restaurants—Thai immigrants have benefited from the class and ethnic resources that made entrepreneurship possible.

Like other Asian ethnic enclave economies, the factors that shape the characteristics of Asian entrepreneurship force many businesses into highly competitive and marginal economic sectors, which contribute to exploitative working conditions. The chief concern for the Thai CDC is the extent that immigrant entrepreneurs and their businesses can play in improving the quality of community life through jobs with better pay and benefits, services that enrich the business climate, and strategies that diversify the community's economic base.

Improving the viability of small businesses could transform them into concerns that help Thai immigrants integrate into urban society and contribute meaningfully to the local economy. The Thai CDC works directly with the smallest and most-in-need entrepreneurs, providing workshops, individualized counseling, access to capital, and links to other public and private small-business services.

As a community bifurcated between early immigrants who are more established, educated, and economically prosperous, and new immigrants who are less educated and economically struggling, it becomes even more imperative to close the social and economic divide by providing access to capital and engaging in wealth generation activities for the economically disadvantaged Thais. Only by eliminating the disparity between the Thai "haves" and "have-nots" can a permanent underclass be prevented and a solid Thai middle class thrive.

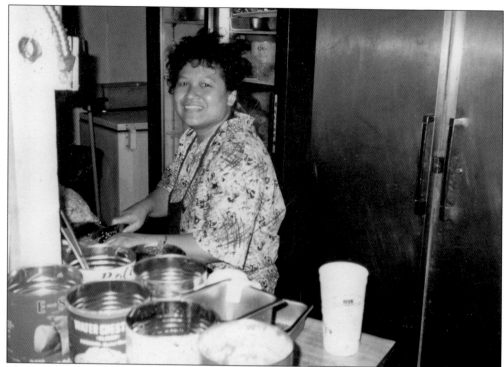

Many Thais work as cooks and wait staff since most of the Thai-owned businesses are restaurants and have become a source of employment for Thais without job and language skills. Their hours are often long, and their wages are often below minimum wage, not nearly enough to survive. (Courtesy of Wanda Pathomrit.)

These Thais are working as parking attendants in front of the Bangluck Market and Sanamluang Café in North Hollywood in 2010. (Courtesy of Jump Photography.)

Pictured in 2010, Udom Meephokee is employed as a security guard for the Wat Thai of Los Angeles. (Courtesy of Jump Photography.)

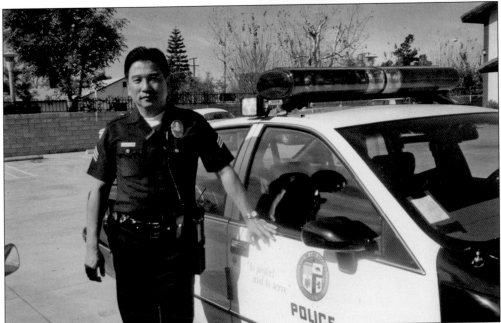

As Thais become established in the United States, they are also able to pursue a profession that helps them arrive at middle class, such as Sergeant Woody, who has been with the Los Angeles Police Department for over 30 years and has just recently purchased the Sizzler in Thai Town with his wife with the hope of building a Thai restaurant and banquet hall. (Courtesy of Panuphon Rugtae-Ngam.)

The Thai CDC is a member and cofounder of the Asian Pacific Islander Small Business Program, a consortium of five Asian ethnic organizations including the Little Tokyo Service Center CDC, Chinatown Service Center, Koreatown Youth and Community Center, and Search to Involve Pilipino Americans, all of whom are dedicated to helping ethnic businesses become viable and sustainable. Representatives of the APISBP are pictured with Congressman Xavier Becerra (center).

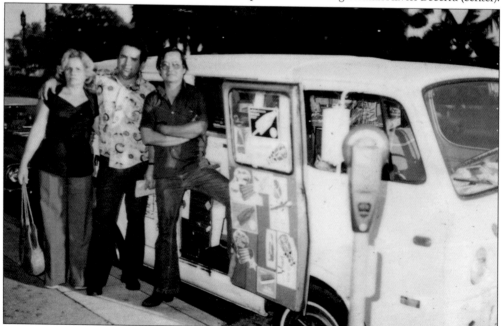

Somnuck Hirunpidok is pictured with friends in front of his new ice cream truck business in Los Angeles in the late 1970s. Somnuck immigrated to Los Angeles in 1971 with his brother-in-law, Sunya Ratchatawan, in order to take advantage of economic opportunities in America. Later on he was able to bring his family to the United States to join him in 1972.

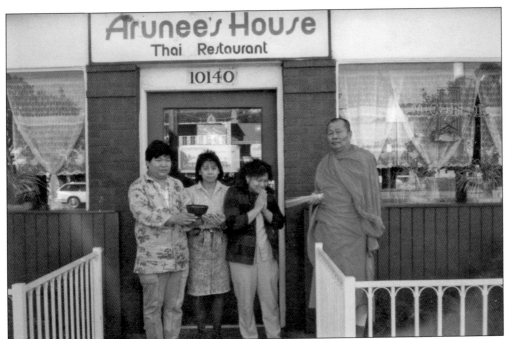

A Thai monk blesses the opening of Arunee House Thai restaurant. Thai restaurants provide the main source of business opportunities for Thais in Los Angeles and all across America. It is also an auspicious Buddhist tradition to have a monk bless a business or a home to provide good fortune in the future. (Courtesy of Wanda Pathomrit.)

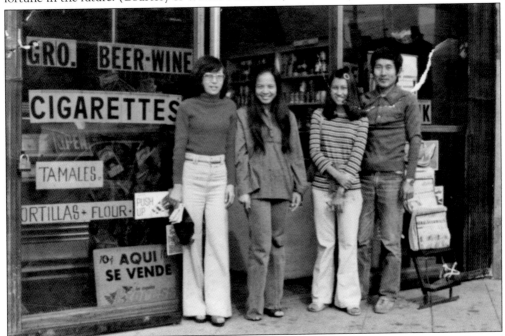

The Hirunpidok family—Sukumal, Somchua, Kusuma, and her husband, Narong—in front of Somnuck's grocery store business, Wong's Market, located in the Westlake/Pico-Union neighborhood of Los Angeles in the mid-1970s.

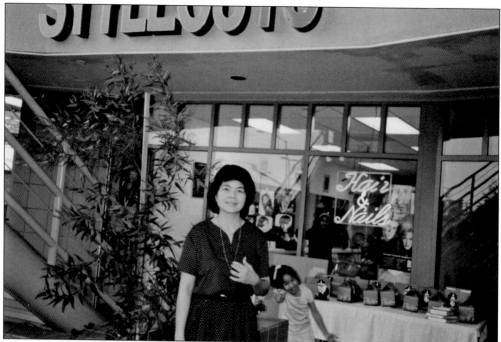

Kamonmahn Musikawong is posing in front of her hair salon business, Stylecuts, in Los Angeles. (Courtesy of the Musikawong family.)

Suthai Musikawong and his mother, Saard Hathaidharm, are at the 1989 grand opening of Kamonmahn's hair salon business in Los Angeles. Aside from restaurant and massage businesses, many Thais have opted to start hair and beauty salon businesses in America. (Courtesy of the Musikawong family.)

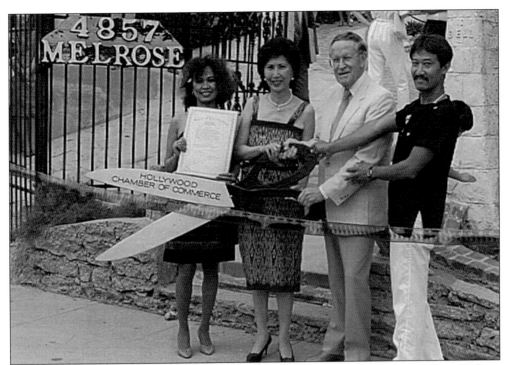

Pasharee Sripipat, also known as "Super Pat," opened the Thai restaurant Siamese Castle on Melrose in Hollywood. The Hollywood Chamber of Commerce joins her in a ribbon-cutting ceremony.

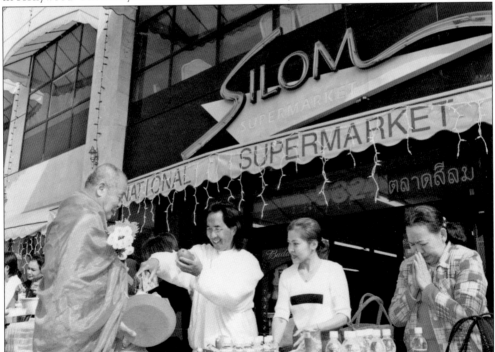

This is a weekly occurrence of alms giving in Thai Town in front of the Silom Market at Thailand Plaza. Thais engage in merit making as a part of their Buddhist religion.

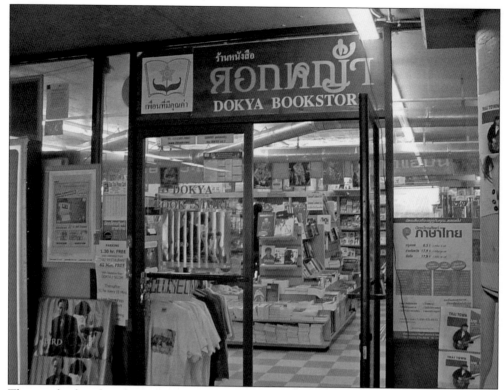

The popular franchise from Thailand, Dokya Bookstore, located at Thailand Plaza in Thai Town, provides Thai immigrants with the familiarity of home to help them adjust and cope abroad. A variety of Thai books, magazines, periodicals, and literature are sold inside the bookstore helping Thais access them abroad. It is also the best place for non-Thais to find Thai language books, dictionaries, and cookbooks.

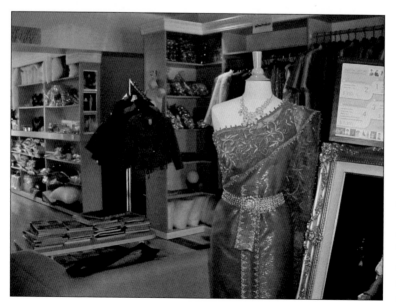

Silk remains a trademark fabric worn by Thais on special occasions; therefore it was only a matter of time before a silk shop opened in Thai Town. Here is the House of Thai Silk where a beautiful array of colors, patterns, styles, and textures of silk are sold.

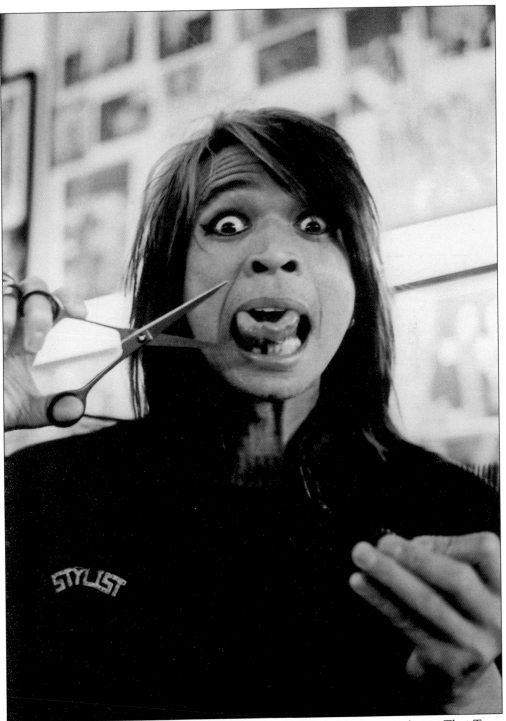

Faroh, a famous hair designer from Thailand, opened up his own beauty salon in Thai Town called Faroh Hair Design. He is known for his famous multi-colored hairdo, black platform boots, outrageous costumes, and Thai folk dancing and singing at various Los Angeles Thai events and festivals. He is pictured here in his hair salon in 2010. (Courtesy of Jump Photography.)

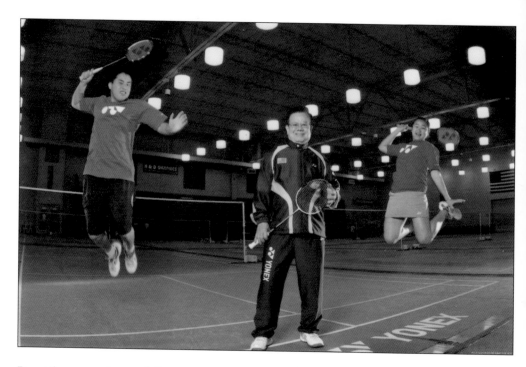

Don Chew, president and CEO of K and D Graphics, has a passion for badminton and created a first rate court in his office complex that includes a printing business and a restaurant in Orange County, California, in 2010. Don Chew was elected president of the Thai American Chamber of Commerce in 2010. (Courtesy of Jump Photography.)

Five

THE IMPORTANCE OF WORSHIP AND CULTURAL MAINTENANCE

The Thai community is rich in religious organizations. Buddhist temples are the largest community institutions as 95 percent of Thais practice Buddhism. The temples serve crucial spiritual, social, and cultural needs but historically have not been active in economic or political activities.

The Wat Thai of Los Angeles is the first and largest Thai Theravada Buddhist Center in the United States, built more than 35 years ago to fulfill the needs of a growing Thai community. After its establishment, the Wat Thai became a magnet, attracting Thais to settle in North Hollywood, where it is located, and in the San Fernando Valley neighborhoods nearby, such as Sun Valley, Panorama City, Arleta, and Van Nuys. Thais purchased their first homes in these areas and started businesses. The Wat Thai conducts religious ceremonies such as prayers and meditation classes and addresses communal concerns affecting the Thai community. Today the center serves approximately 70,000 Thais in the Los Angeles area.

As a long-established community institution, Wat Thai of Los Angeles has not only become a social gathering center, but also emphasizes education of the new generations of Thais and non-Thais about Thai beliefs, values, and culture. Open to the public, the Wat Thai of Los Angeles is well known for its Thai language program, created in 1974 for second-generation Thais and non-Thais. It also hosts courses on traditional painting, dancing, and music, in which Thai parents enroll their children, and which attracts diverse non-Thais every year.

The Wat Thai is also a popular site for viewing Buddhist ceremonies and receiving hands-on experience in Thai culture in Los Angeles.

Other Buddhist temples have now sprung up in Southern California to serve the growing Thai community, now dispersed throughout the Southern California region with concentrations in parts of the San Gabriel Valley, Orange County, and San Diego County, and along the Long Beach and South Bay corridors. In addition to serving as places of worship, some temples also promote cultural maintenance by hosting traditional Thai festivals and religious ceremonies.

There are also a number of Christian churches and mosques in Southern California to serve Thais of other religious faiths.

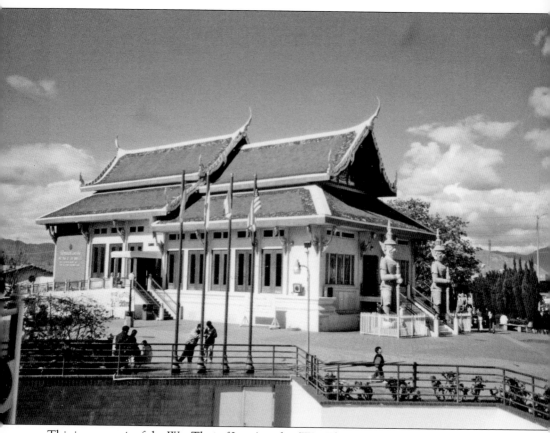

This is a portrait of the Wat Thai of Los Angeles (Wat Thai of LA) located in North Hollywood, California. Housing the shrine, the temple is built in traditional Thai Buddhist architecture, and sacred religious worship and ceremonies are performed in this building. With its green, red, and orange-tiled roof recreated in the Rattanakosin style, it is as though a helicopter airlifted one from Bangkok and dropped it in North Hollywood. Other parts of the temple grounds hold Thai language and traditional music and dance classes, and year-round performances and festivals are open to the public.

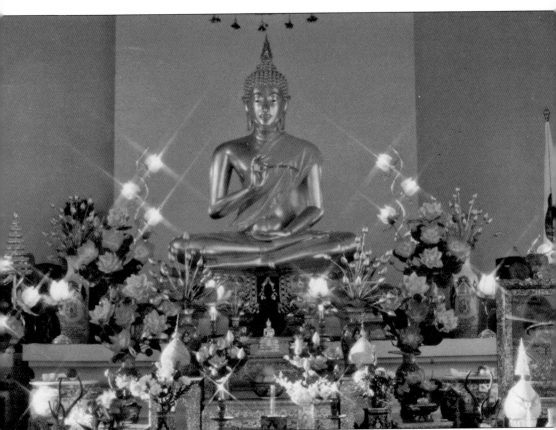

This is the image of the elevated gold leaf Buddha statue in a meditation pose surrounded by lotus flowers symbolic in Buddhism of enlightenment since lotus flowers rise from stagnant waters. It is located in the shrine of the Wat Thai of LA and worshiped by Thais and non-Thais alike who share the Buddhist faith.

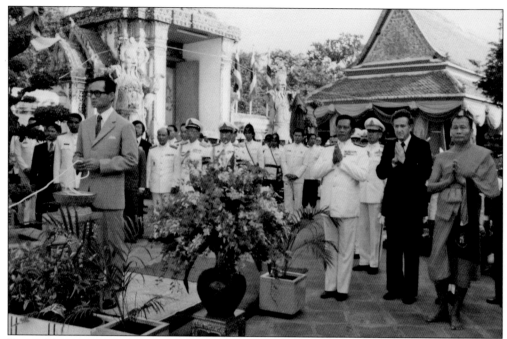

Pictured here are King Rama IX, the prime minister of Thailand, and the president of Wat Thai of Los Angeles who were chosen to preside over a special ceremony to bless the Buddha statue that currently resides at Wat Thai of Los Angeles. This ceremony occurred in the 1970s.

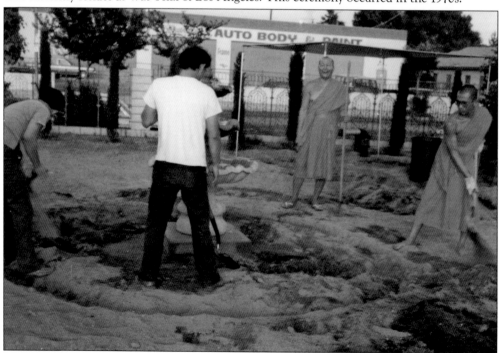

In 1980, Thai laymen and monks had a hand in clearing the land for the building of the Wat Thai of Los Angeles. They are breaking ground to begin laying the foundation for the temple grounds. This was the very first work done on the temple grounds soon after the land was acquired.

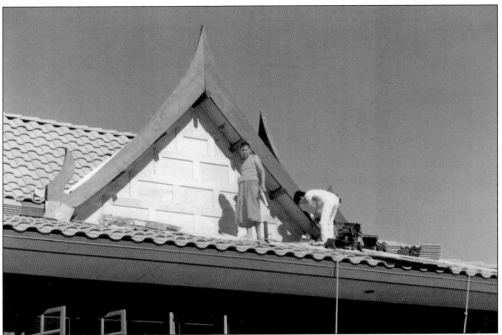

Around 1987, a Thai monk and layman are finishing the classical Thai roof of the classroom building of the Wat Thai of LA, located across from the shrine in this photograph. A wat (temple) is a collection of buildings within an enclosure serving dual purposes: Buddhist monastery, temple, and community center. Their construction is often funded by wealthy patrons—contributing to a wat is a good way to make merit.

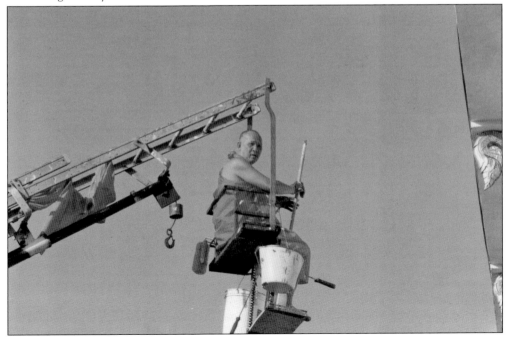

The beloved abbot is perched in the bucket of a crane as he inspects the retiling and maintenance of the school and the roofs of the buildings.

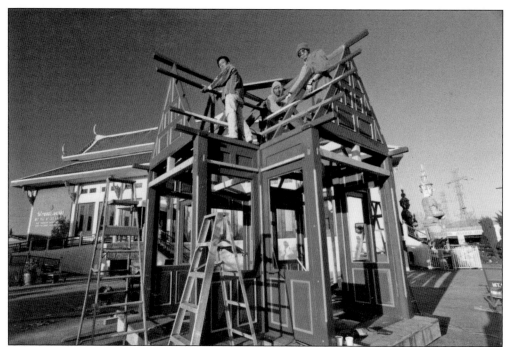

Thai monks and a layman help to build a house for Guan Yin, another Buddhist deity, on the temple grounds around the year 2000 so people can worship her and pray for her in addition to Buddha.

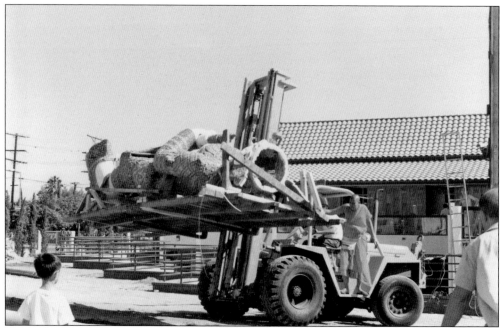

In 1986, the president of Wat Thai attended a cultural exposition in Vancouver, Canada, where he saw some magnificent monuments on display. He decided to ask the exposition if he could have them, and those statues were subsequently donated to Wat Thai of Los Angeles where they stand today, guarding the entrance to the temple.

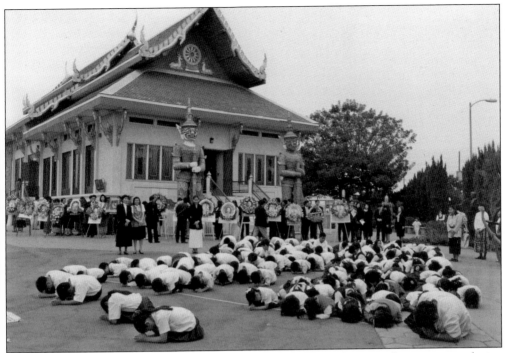

The uniformed Wat Thai of LA schoolchildren bow down on the ground in reverence during opening exercises before class. (Courtesy of Wanda Pathomrit.)

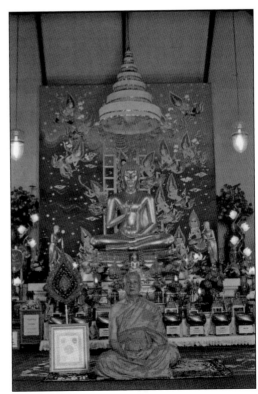

The abbot of Wat Thai of LA is posing inside the shrine in front of the Buddha statue. Phrarajdhammavides Sodkhomkum "Amon" has served as an abbot of the temple since 1988. (Courtesy of Jump Photography.)

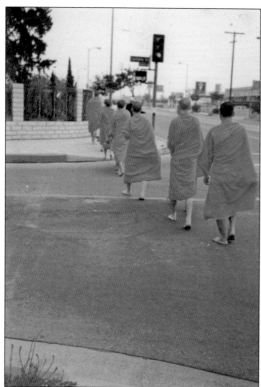

This photograph, taken around 1981, shows the very first program in which the monks went out into the neighborhood providing people with the opportunity of creating good merits in their own community. This was part of a campaign to do what the monks in Thailand do.

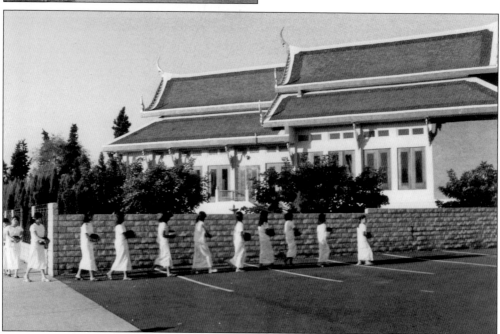

This image shows Thai nuns walking around the Wat Thai of LA to receive their alms. Thai monks and the less traditional nuns receive alms from Thai worshippers as a form of merit making. These alms serve as the monk's meal for the day or provide personal supplies for the monks to use in their daily life.

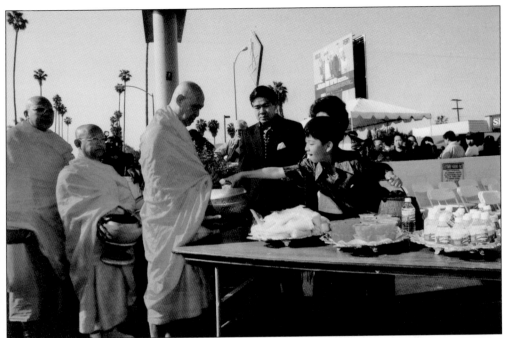

The abbot and his monks receive alms from the Thai consul general of Los Angeles, Isintorn Sornvai, and his family at the Thai New Year's Day Songkran Festival in Thai Town in the early 2000s.

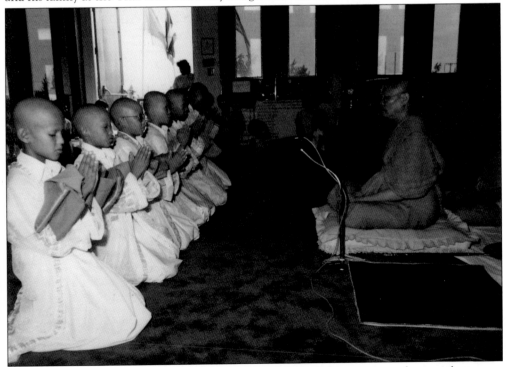

Young novices are being ordained into the monkhood for 10 days or up to a few months to earn merit for themselves and their families. All Thai males of the Buddhist faith are required to enter the monkhood during their adolescence as a major rite of passage.

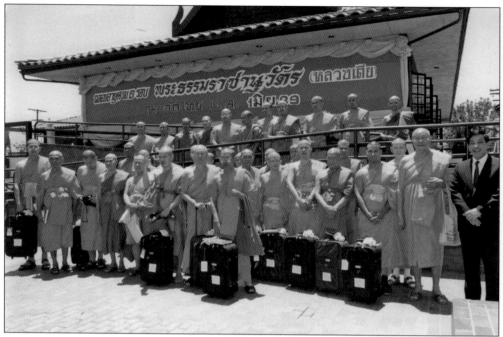

This is a photograph of the 1997 birthday celebration of the president of Wat Thai of LA. The monks and the Thai consul general Suphot Dhirakaosal pose for a picture. Each suitcase contains a gift.

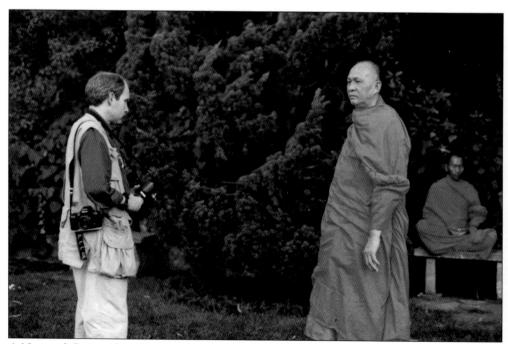

A National Geographic photographer invited the current president of Wat Thai of LA to take pictures in Malibu for his article on Thai Buddhism.

Her Royal Highness Princess Ubolratana Rajakanya, from the Thai royal family, presides over a ceremony in the shrine of the Wat Thai of LA in a *wai* position. In the presence of any member of the royal family, all Thais are required to kneel down and be in the bowing position as a show of reverence while the member of royalty is elevated above their subjects. Consul General Suphot Dhirakaosal is in the front right of the photograph in the mid-1990s.

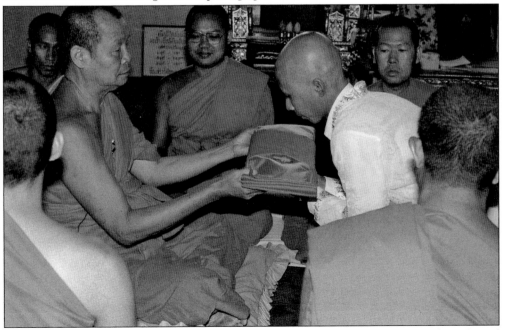

This image shows a novice Thai monk receiving his saffron robe from one of the head monks and with other monks presiding following his ordination ceremony at the Wat Thai of LA.

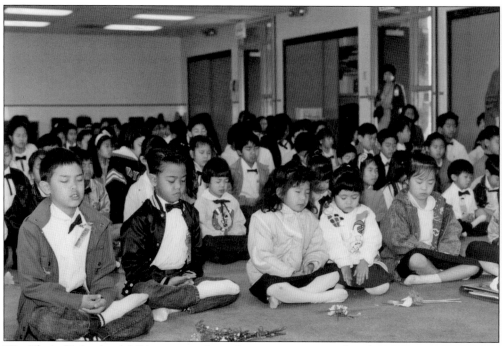

Wat Thai of LA schoolchildren are in their classroom in a state of meditation, a very important part of practicing Buddhism.

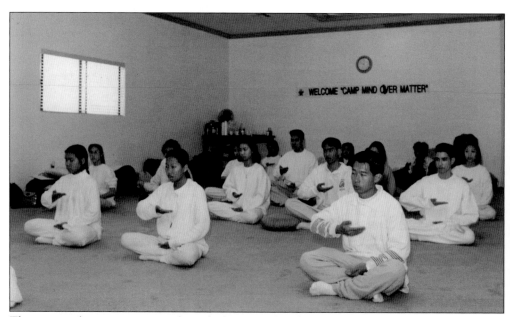

Thai men and women are going through the steps of meditation as part of the Mind Over Matter Camp at Wat Thai of LA. To reach enlightenment (nirvana), Buddhists try to develop morality, meditation, and then wisdom (the three pillars).

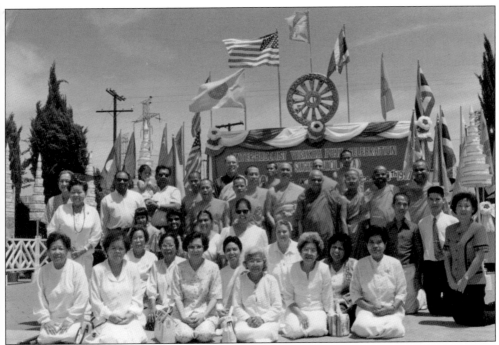

This photograph was taken at a meeting of representatives from different religious institutions from various American states, China, Sri Lanka, and Thailand. If you look carefully you may notice that they are standing in front of a board holding up a Buddist dharma wheel, or the "wheel of law."

Pictured in 2010, Chawapot Thoongsuwan, the informal archivist and historian of the Thai community in Los Angeles, is very active on the board of the Wat Thai of Los Angeles. (Courtesy of Jump Photography.)

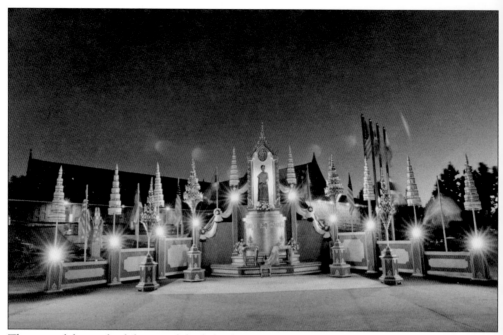

These are elaborate backdrops each built for the auspicious occasions of King Bhumibol Adulyadej's and Queen Sirikit's birthday celebrations at the Wat Thai of LA opened to the public. The king's birthday is December 5, and the queen's birthday is August 12. The occasion is always well attended by Thai and local dignitaries, prominent members of the Thai community, and the general public. Thais believe that Buddhism is one of three forces that give their kingdom its strength; the other two being the monarchy and nationhood.

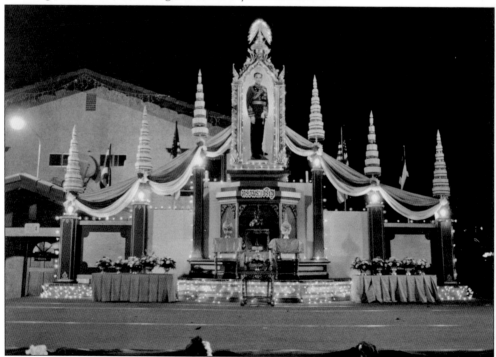

Six

COMMUNITY ARTS AND CULTURE

Vibul Wonprasat founded the Thai Community Arts and Cultural Center (TCACC) to promote and preserve Thai culture, arts, and customs through education and a Thai Cultural Day held every year. The organization attempts to target younger generations of Thais and non-Thais to fulfill its mission of bridging the gap between diverse communities in Los Angeles.

One of the well-known activities of TCACC is its annual event, Thai Cultural Day, which was started in 1993 by Wonprasat. This event usually takes place in September at the Barnsdall Art Park in Hollywood, just east of Thai Town, and showcases a variety of Thai cultural activities. Activities include vegetable carving, cooking demonstrations, folk dances, and children's folk games. The Thai Cultural Day is an all-day event open to the public.

The TCACC works to preserve Thai art and to pass down the knowledge of Thai arts to the community. To make this possible, the cultural arts center collaborates with other museums and academic departments to display Thai arts and crafts at exhibitions throughout Southern California. Such sites include the Pacific-Asia Museum, Los Angeles County Museum of Art (LACMA), and the UCLA Armand Hammer Museum.

Kangwal Kerdpon, the longtime classical Thai dance instructor for the Wat Thai of LA, poses in uniform with his students in front of the temple. He has a reputation of working his students very hard, and it shows in their performances, which are always perfectly delicate and graceful. Their free performances are always in high demand and are often requested within and outside the community for events and festivals. (Courtesy of Jump Photography.)

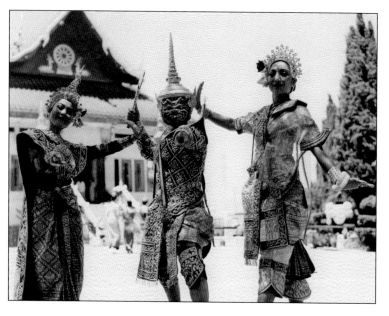

Professional classical Thai dancers in elaborate and ornate costume from the classical tale *Ramakien*, an ancient moral epic with its origins in the Indian Ramayana, are posing in front of the Wat Thai of LA shrine. (Courtesy of Jump Photography.)

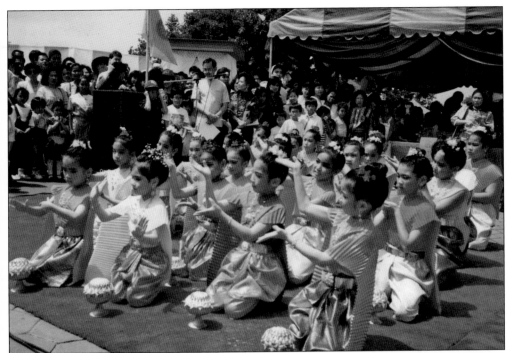

Children from the Thai dance school at Wat Thai of LA are in costume performing a classical Thai dance for a celebration at the temple.

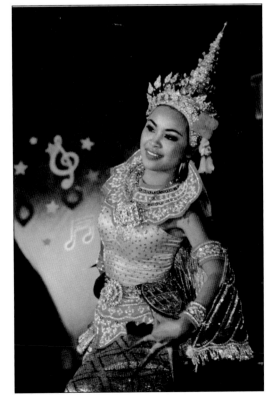

A classical Thai dancer in an elaborate and ornate costume performs the Menora bird dance. She is often requested for events and festivals, including the ribbon-cutting ceremony for the designation of Thai Town in January 2000, when her photograph appeared in the Los Angeles Times.

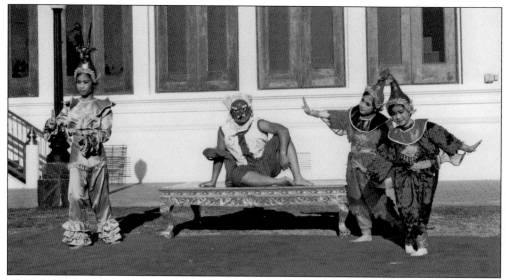

Thai children are performing a classical Thai dance in front of the Wat Thai of LA shrine. (Courtesy of Monk Phra Boonlerm.)

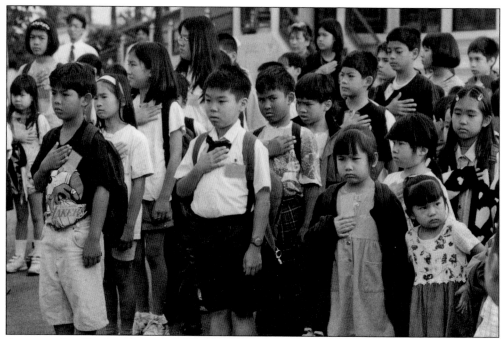

An example of both cultures converging: Wat Thai of LA schoolchildren say the "Pledge of Allegiance" as part of their opening exercises.

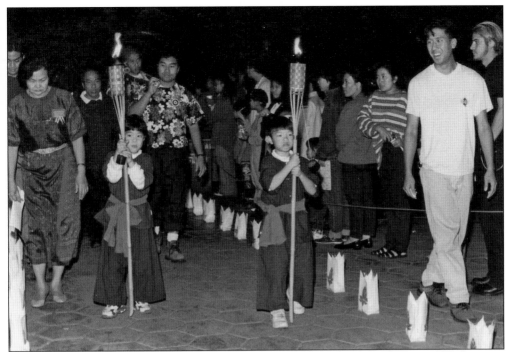

Thai children are in front of a procession dressed in peasant farmer costumes at a celebration at Wat Thai of LA. (Courtesy of Monk Phra Boonlerm.)

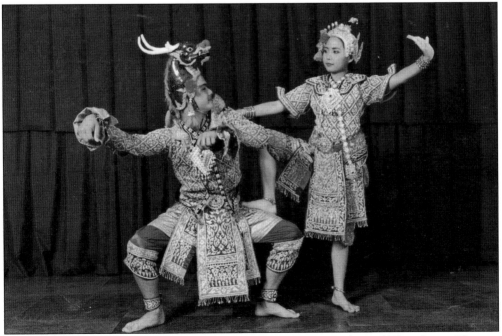

Thai dancers in elaborate and ornate costumes are performing a classical Thai dance. The two principal forms of classical Thai drama are *khon* and *lakhon*. Khon was first performed in the royal court in the 15th century, with story lines taken from the Ramakien. The more graceful lakhon, which also features elements from the *jataka* tales, was originally performed inside the palace.

A Thai monk is throwing a woven rattan ball known as *takraw* to a Thai boy on the grounds of Wat Thai of LA. The takraw is an acrobatic Southeast Asian sport played on the grass with the idea of keeping the ball in the air using any part of your body except your hands. It requires extraordinary agility, balletic leaps, and speed of reactions. (Courtesy of Monk Phra Boonlerm.)

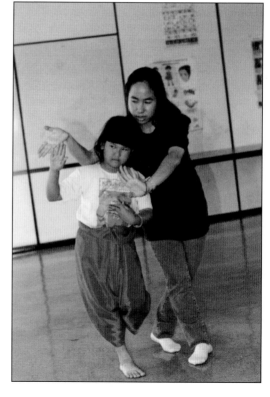

An instructor is teaching the fundamentals of classical Thai dance to a young Thai girl at Wat Thai of LA. Classical Thai dance is known for requiring agility in the hands and feet. Graceful curves of a dancer's hands are seen in *lakhon* performances and in "nail dances."

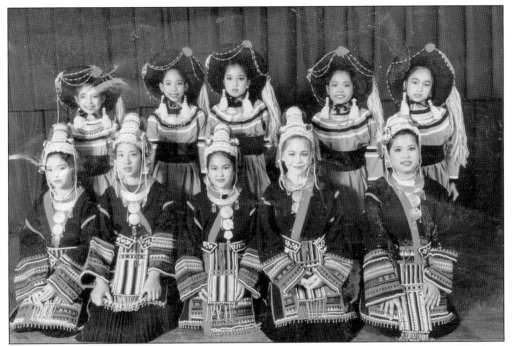

This is a group photograph of members of a Thai Hmong hill tribe from the Northern tip of Thailand in their traditional costumes. Outside of their remote villages, hill tribes have a difficult time adjusting to the modern world. Their culture differs from the mainstream of everyday Thai life.

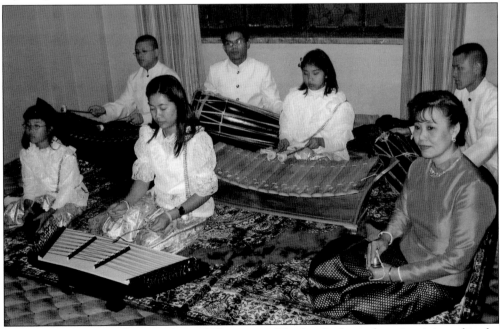

Thai musicians are performing classical Thai music. Thailand's classical music originated in the Sukothai era. The basic melody is set by the composer, and no notation is used. Each musician varies the tune and adopts the character of the instrument. Three of the instruments pictured here are flat and curved *ranats* or xylophones. Each kind produces different tones.

Preserving and showcasing Thai culture also becomes very important for a second generation of Thais, which in this case are UCLA Thai Smakom students on a UCLA stage singing a traditional song in the early 1990s. (Courtesy of Chanchanit Martorell.)

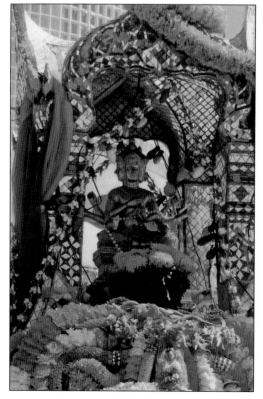

Thai culture is also on display in the form of a Thai goddess statue seated within a mirror mosaic shrine on a pedestal. Thais seeking prosperity place their garlands and say a prayer in front of Thailand Plaza in Thai Town.

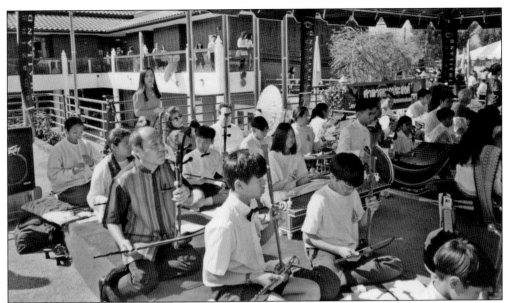

Musicians are performing classical Thai compositions at Wat Thai of LA. Pictured in the foreground are musicians playing a Thai instrument called the *saw* or Thai violin, which is a two-stringed instrument. The head is made of a coconut shell.

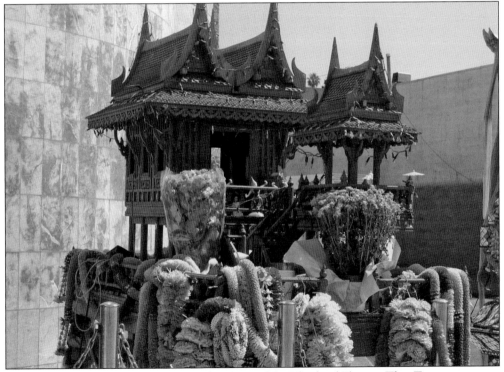

A traditional Thai spirit house is placed in front of the Thailand Plaza in Thai Town as a way to ward off bad spirits from entering the business and bringing bad luck or misfortune to its owner and occupants. There are many different styles of spirit houses in Thailand in front of homes and businesses.

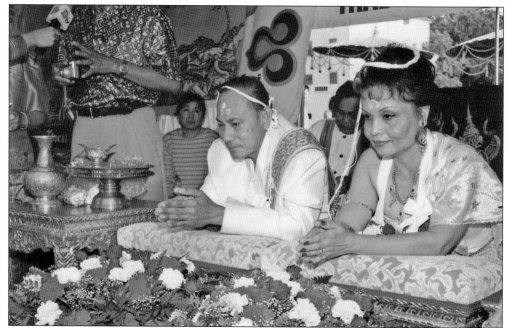

A traditional Thai Buddhist wedding ceremony is demonstrated at the annual Thai New Year's Day Festival. In the ceremony, the couple is on their knees leaning forward with their palms clasped in a wai while their guests, friends, and family members walk by to pour water that has been blessed by a monk down their clasped hands and offer them their well wishes.

Vibul Wonprasat, the executive director of the Thai Community Arts and Cultural Center, and his volunteers and board, along with the staff and volunteers of the Thai Community Development Center, meet at the Wat Thai of LA to plan the 18th Annual Thai Cultural Day scheduled for September 2008.

Seven

FESTIVALS AND CELEBRATIONS

To further promote and heighten the awareness of Thai culture and its rich heritage and traditions, the Thai community also celebrates the annual Thai New Year's Day or Songkran Festival in Thai Town. It evolved from the Thai Town Festival originated by the Thai CDC together with the Thai Town Merchant Association. Held the first Sunday of April every year, the festival has become the largest celebration and showcase of all facets of Thai culture outside of Thailand and now attracts 100,000 visitors from throughout Southern California.

Thai New Year is officially April 13. The organization created to host the festival, the Thai New Year's Day Songkran Festival Committee, held its seventh annual festival in 2010. Every year the committee collaborates with Thai corporations and the Thai government for financial and program support and with the local city government for logistical support to make possible the closure of up to 13 blocks of Hollywood Boulevard for the festival grounds. The festival boasts over 250 food and handicraft booths, a Thai kickboxing ring, stages for folk, cultural, and contemporary entertainment, a beauty pageant, a parade, and religious ceremonies.

Festivals at the Wat Thai of Los Angeles in North Hollywood also provide a way for the community to congregate and for non-Thais to receive a better understanding of Thai culture. Such festivals include the Loy Krathong Festival, Songkran Festival, and Asanha Puja Day.

These festivals also demonstrate the political efficacy of the Thai community in Los Angeles to all levels of the U.S. government to help secure benefits and resources for the development of the Thai community. The main festival held in Thai Town also increases the spotlight on Thai Town and Hollywood Boulevard, encouraging visitors to explore Thai Town and boost the local economy.

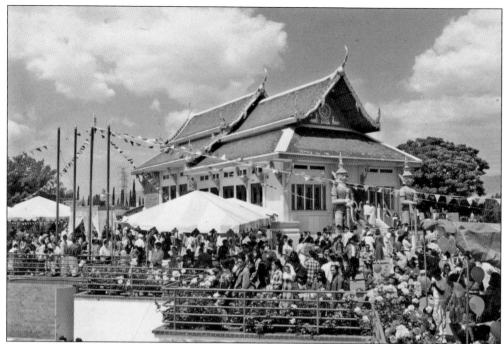

This is a typical crowd encountered at one of many festival celebrations at the Wat Thai of LA. This photograph was taken at one of the very first annual Songkran Festivals at Wat Thai in the 1980s. (Courtesy of Monk Phra Boonlerm.)

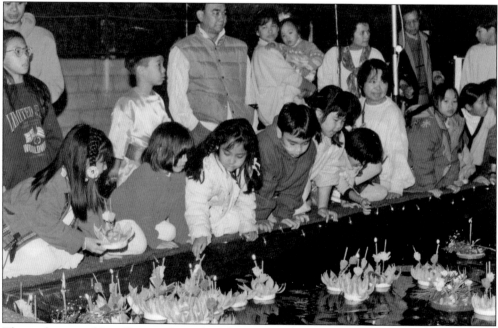

This is the annual Loy Kratong festival celebration at the Wat Thai of LA. This festival is held on a full moon night of the 12th lunar month in mid-November. At this festival, Thais float little containers, usually made of palm leaves in the shape of a lotus flower, with a candle, joss sticks, and a coin placed in them to thank the river goddess and shed their past year's sins.

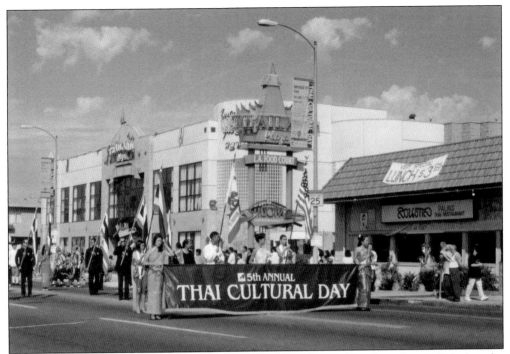

This is the 5th Annual Thai Cultural Day Parade on Hollywood Boulevard in 1997 before the designation of Thai Town. The Thai Cultural Day Festival is still celebrated annually each September in Hollywood.

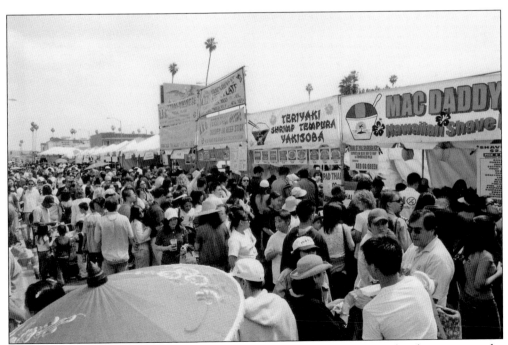

The annual Thai New Year's Day Songkran Festival has become so popular that it is now the largest festival outside of Thailand and draws over 100,000 visitors.

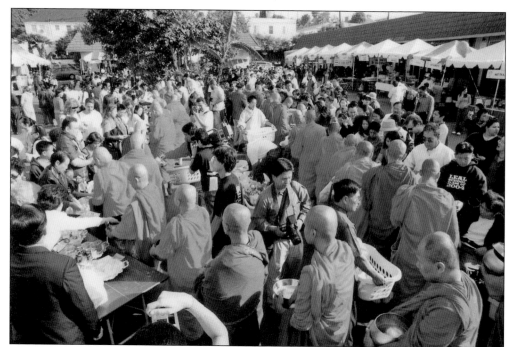

Before the annual Thai New Year's Day Songkran Festival gets underway, Thais believe they have to make merit first and not tempt fate. Thais from all over arrive early in the morning before the start of the festival to give alms to the monks, who then perform a blessing ceremony.

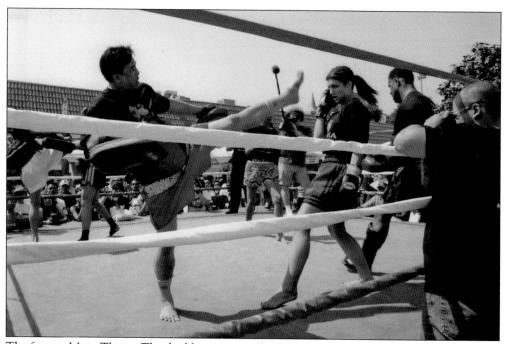

The famous Muay Thai or Thai kickboxing is on display on Hollywood Boulevard in Thai Town as part of the annual Thai New Year's Day Songkran Festival. This martial art is very popular and is often surrounded by crowds of excited spectators.

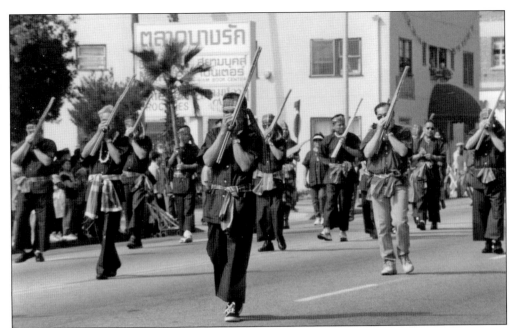

This photograph features Thai men in peasant farmer clothing with traditional *pakamas* tied around their waists playing the *kaen* in the annual Thai New Year's Day Songkran Festival parade. The kaen, also known as a mouth organ, is a Thai folk instrument popular in Northeast Thailand dating back 2,000 to 3,000 years.

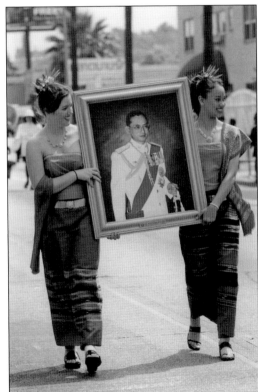

Two young Thai women are holding up a portrait of the ninth reigning King of Thailand, His Majesty Bhumibol Adulyadej, in the annual Thai New Year's Day Songkran Festival parade procession in Thai Town.

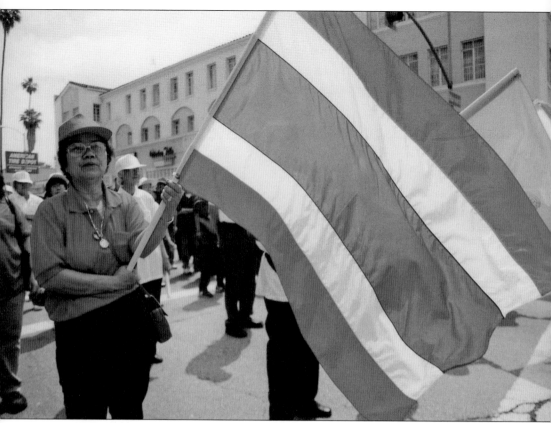

A woman shows Thai national pride by holding up a Thai flag in the annual Thai New Year's Day Songkran Festival parade procession on Hollywood Boulevard in Thai Town. The flag showcases five stripes colored red, white, blue, white, and red in that order. These three colors represent the nation, religion, and king of Thailand. This was adopted as the national flag in September 1917.

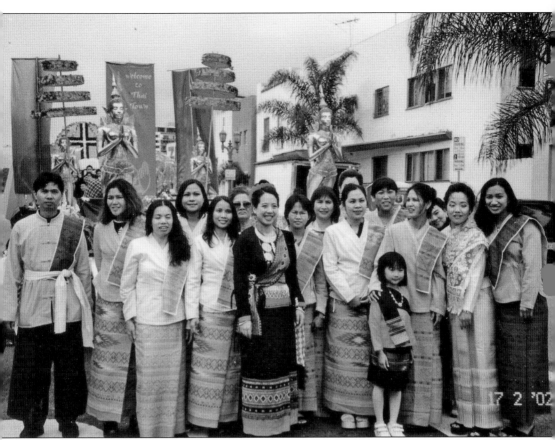

Chancee Martorell is dressed in Northern hill tribe costume and pictured in front of the Thai CDC float in the Hollywood Lunar New Year Parade with Thai CDC staff, workers from the El Monte Thai Slavery Case, and their friends dressed in Northern Thai attire. KSCI Channel 18 sponsored the float in 2002.

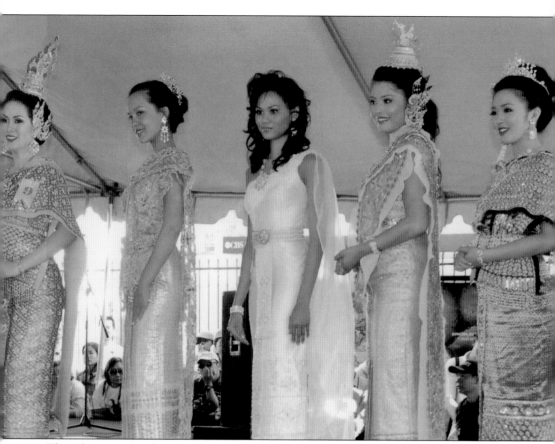

This photograph taken by Nuno, a Los Angeles based Thai photographer, features several contestants in the 2009 Miss Thai New Year USA beauty pageant at the 6th Annual Thai New Year's Day Songkran Festival.

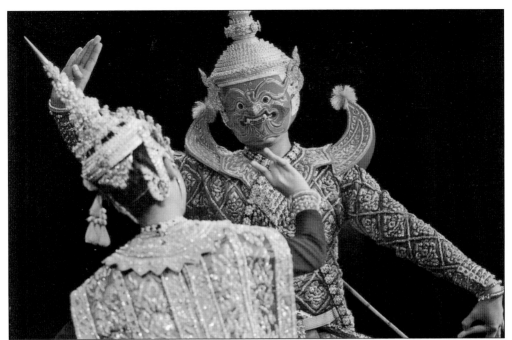

Two classical Thai dancers perform the legendary *Ramakien* tale in the Barnsdall Art Park Gallery Theatre at the Annual Thai Cultural Day in 2008.

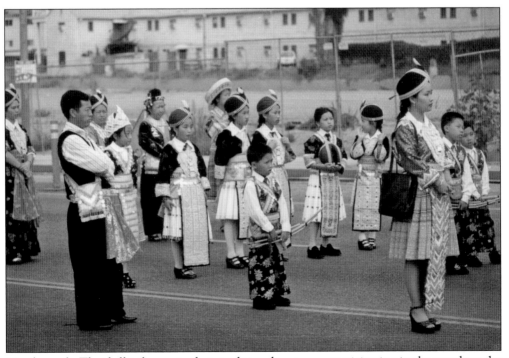

Members of a Thai hill tribe are in their traditional costumes participating in the parade at the Annual Thai Cultural Day in Hollywood.

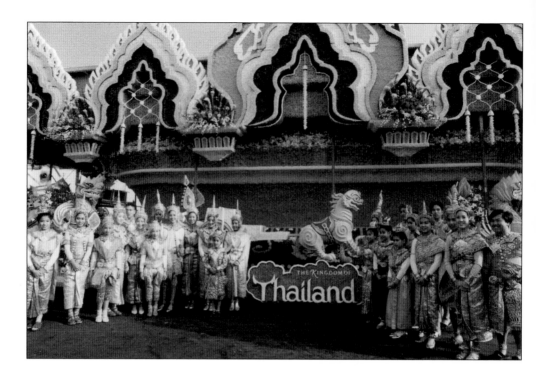

Thai Airways International sponsored this float in the world famous Pasadena Rose Parade. Participants who rode on the float are dressed in very ornate and elaborate costumes to showcase their Thai heritage to over a billion people worldwide.

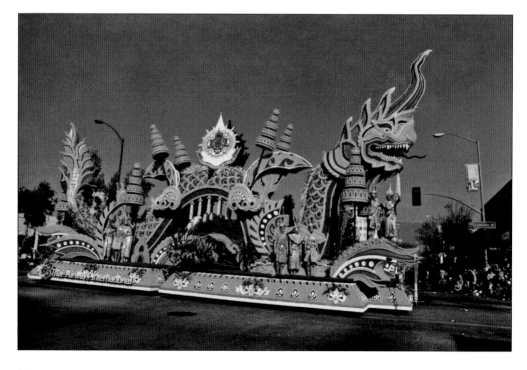

Eight

INSTITUTION BUILDING

The key to the successful development of any community is its ability to control its own development. Middle and upper-class communities often have the resources to secure the changes they want for their neighborhoods. Low-income neighborhoods like the Thai community usually do not. There is a critical need for developing institutions rooted in the Thai neighborhoods so that Thais can direct their own community development. These institutions must be able to carry out key developmental functions including: delivering services to help people overcome economic obstacles, conducting direct community building work, and planning and directing the community's overall development. In all these activities, institutions must be accountable to ensure the participation of the Thai community.

Since most low-income Thais are recent immigrants with limited English skills, providing services in the Thai language becomes a practical necessity. Further, the sense of a common ethnic identity, particularly among recent immigrants, is an important foundation for effective organization. However, low-income neighborhoods like the Thai community face many obstacles in building institutions that can serve their needs, primarily due to a weak institutional infrastructure with limited resources at its disposal.

Most of the existing institutions are loosely organized networks. Others are geared towards business, like the Thai American Chamber of Commerce of Southern California; Thai university affiliations, like the various alumni associations; and regional identities, like the Northern Thai Association. The longest-established organization, providing mutual aid to Thais for over 30 years, is the Thai Association of Southern California, which is membership based.

One institution that has had a relatively long history and an established reputation with substantial funding from public and private sources is the Thai Community Development Center. The CDC is engaged in community asset building and wealth generation, as well as physical development, including affordable housing and community development planning for these low-income neighborhoods. It was specifically established to begin addressing the health and human service needs of the Thai population and to help Thais access economic opportunities for self-sufficiency. It is also engaged in broader advocacy and civil rights work.

Another established institution is the Thai Health and Information Services, Inc., which helps immigrants develop health advocacy skills in an effort to promote personal health responsibility.

Much needs to be done still to build and strengthen these institutions and organizations.

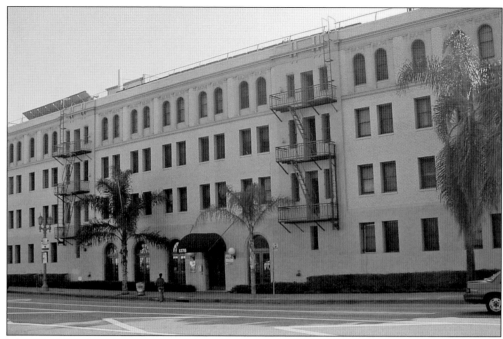

Thai CDC purchased the c. 1923 Halifax Apartments in 1997 together with the Organization for Neighborhood Empowerment and completed a $5 million historic rehabilitation of the building that converted 72 single units into 46 multifamily units for low and very low income individuals and families. Thai CDC's offices are also housed in the building.

This photograph features the Thai CDC holding a workshop with the Thai Senior Citizens Club at the Wat Thai of LA to assess their need for affordable housing. "Pa Aroon," who is widely considered to be the oldest member and patriarch of the Thai community, started the club.

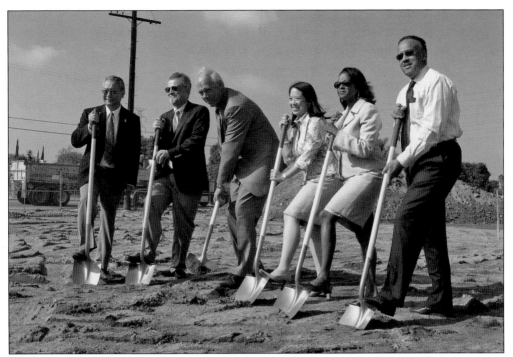

The Thai CDC breaks ground in 2006 on its $10 million Palm Village Senior Housing Project in Sun Valley near the Wat Thai of LA with its partner, the Little Tokyo Service Center CDC, and the governmental entities that financed the project, the U.S. Department of Housing and Urban Development and the Community Redevelopment Agency of Los Angeles.

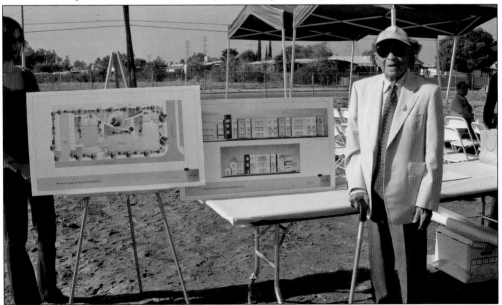

At the 2006 groundbreaking ceremony, Pa Aroon stands proudly next to the architectural renderings of the Palm Village project. For him, this was a dream come true having worked with Thai CDC to help identify the need for affordable senior housing in the San Fernando Valley and sending much encouragement along the way.

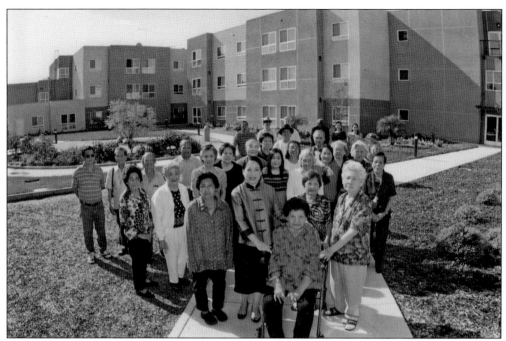

After eight years, Thai CDC finally opened its doors in 2008 to Palm Village, the first affordable senior-housing project in the Thai community. The $10 million, sixty-unit complex also boasts amenities such as a multipurpose room, a library, a computer lab, and a community garden. (Courtesy of Jump Photography.)

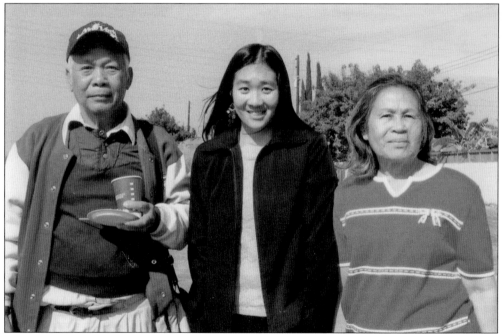

Program director Rachanit Keh Trikandha, who worked hard to get the affordable senior housing project off the ground, is photographed with a Thai senior couple who applied for the housing and attended the groundbreaking ceremony in 2006.

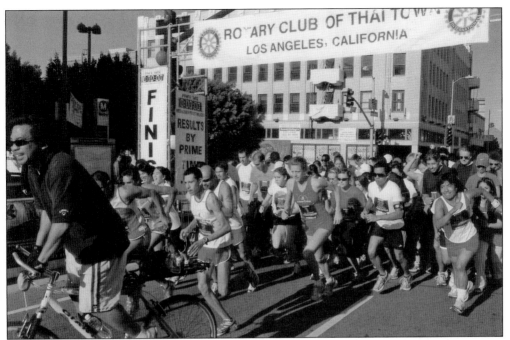

The first Thai Town Rotary Club 5K Run/Walk for charity was held early in the morning before the start of the 5th Annual Thai New Year's Day Songkran Festival in 2008 on Hollywood Boulevard in Thai Town. Runners from throughout Southern California and beyond participated in the race. The Rotary Club of Thai Town was founded in 2007 to fulfill the rotary motto of "service before self" on behalf of Thais here and back home.

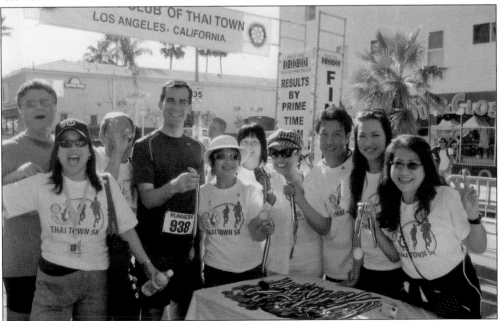

Los Angeles Council president Eric Garcetti, who ran in the race, is photographed here with the Thai Town Rotary Club members and supporters following the 5K Run/Walk. They are preparing to present medals. His staff, called Team CD 13, also ran in the race.

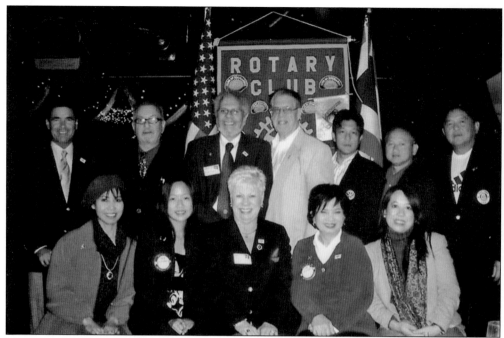

Members of the Rotary Club of Thai Town are taking a group photograph following a meeting in 2009 with officials from the International Rotary Club at Thailand Plaza in Thai Town.

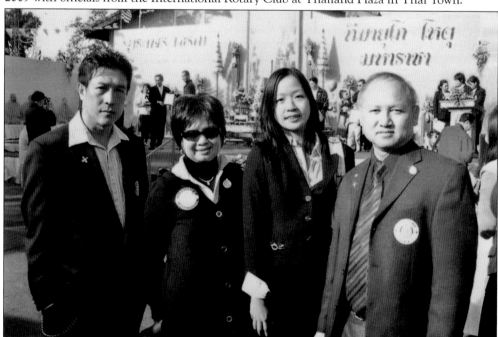

The Rotary Club of Thai Town officers came together at a community event at the Wat Thai of LA. Second from the left is Sue Kanchana, the first president of the club, and next to her is Teresa Chung, a very active community member who is part of the Thai Community Arts and Cultural Center, former president of the Thai Association of Southern California, and the second president of the Thai Town Rotary Club.

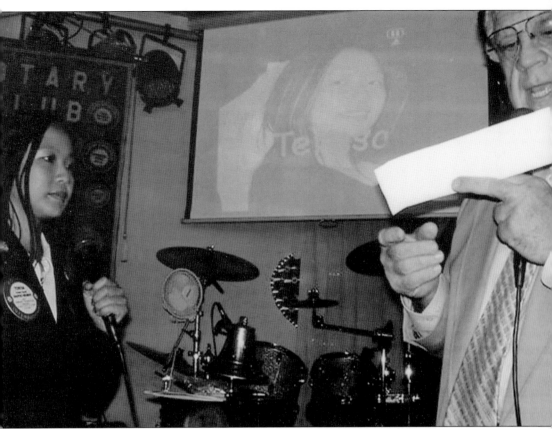

Teresa Chung was sworn in as the second president of the Rotary Club of Thai Town in 2009. Her predecessor was Sue Kanchana, a very active member of the Thai community.

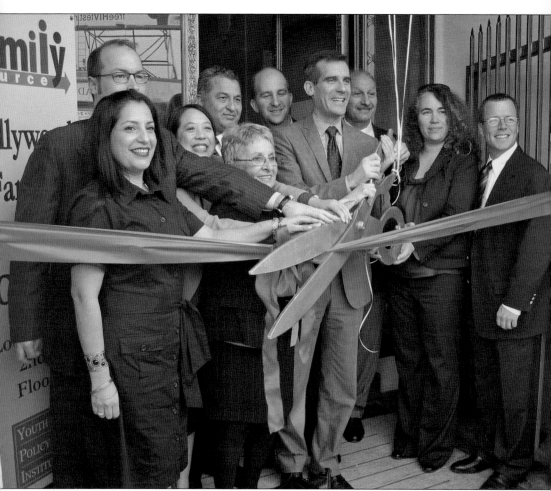

A ribbon-cutting ceremony was held on February 11, 2010, to open the Hollywood Family Source Center in Thai Town, providing a one-stop center for comprehensive social and human services. These services aim to help low-income residents with housing, jobs, public benefits, computer skills, and tutoring and after school programs for their children.

Nine

THAI TOWN

The designation of Thai Town was the vision in the early 1990s for a growing Thai community whose immigrant history spanned more than 30 years in the United States. Author Chanchanit (Chancee) Martorell, who in 1994 founded the Thai Community Development Center, began a feasibility study in 1992 to establish a city designation of Thai Town by conducting the first Thai community needs assessment survey. The survey revealed overwhelming support for a Thai Town and for it to be more than just a commercial center. Rather, a Thai Town would preserve the Thai community's cultural integrity while enhancing an ethnically diverse area.

On October 27, 1999, after a seven-year campaign, Thai CDC successfully obtained an official City of Los Angeles designation for a six-block expanse on Hollywood Boulevard in East Hollywood—from Western to Normandie Avenues—as "Thai Town." It is the only municipally recognized Thai district in the United States.

East Hollywood has historically served as a port of entry for newly arrived Thai immigrants and an enclave for Thai-owned businesses and workers for more than 40 years. East Hollywood, with its Thai restaurants, markets, and gift shops, is arguably the cultural center for Thais living in Los Angeles. The goal in establishing Thai Town was to promote neighborhood pride, economic development, cultural exchanges, and tourism. It is important to the Thai community not only because it provides a cultural experience, but also because it acknowledges the history of the Thai community in Los Angeles.

Moreover, obtaining the Los Angeles designation of Thai Town is one of the most notable achievements by the Thai CDC in the area of linking cultural tourism to community development. Through cultural tourism, Thai CDC envisions Thai Town as an economic development strategy to revitalize a depressed section of Hollywood.

Thai Town, therefore, became more than just a designation but a community economic development strategy, placing the well-being of people and quality of life within the area as a main objective. In its role as an advocate for the Thai community, Thai CDC believes that the development of Thai Town should address the fundamental needs of its residents for decent jobs, economic security, and decent and affordable housing. Thai Town helps achieve the three E's for the Thai community—empowerment, education, and entrepreneurship.

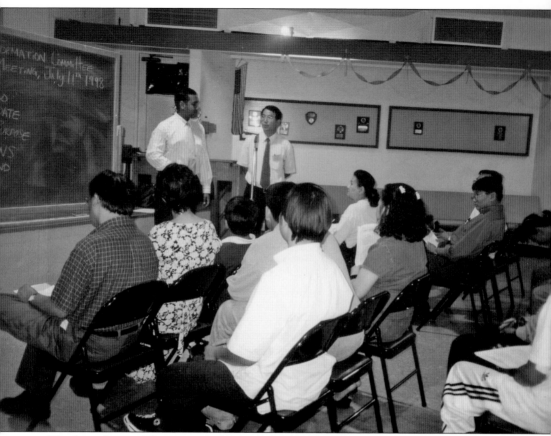

The first of many Thai community meetings held by Thai CDC to resurrect the Thai Town designation campaign from 1992 was on July 11, 1998. Through this meeting and several more, Thai CDC was able to recruit members from various segments of the Thai community onto the Thai Town Formation Committee. Members of the committee were trained in civic engagement to help campaign for the designation. Thai CDC staff members conducting the meeting included Ernesto J. Vigoreaux, who is half Thai and half Puerto Rican, and Sak Vasunilashorn.

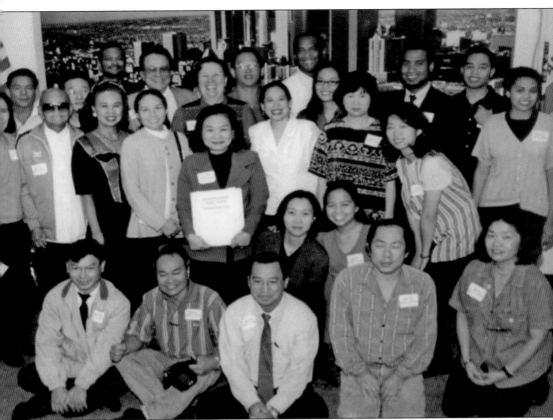

Victory at last! The Thai CDC, along with Thai Town Formation Committee members, supporters from various communities, and the staff of Council District 13 were jubilant after winning the designation of Thai Town in East Hollywood on October 27, 1999, after a protracted campaign that began in 1992. The group photograph was taken in the pressroom behind the Los Angeles City Council Chambers after the council voted unanimously in favor of the motion to designate East Hollywood as Thai Town, a motion entered by councilwoman Jackie Goldberg, whose district included Thai Town.

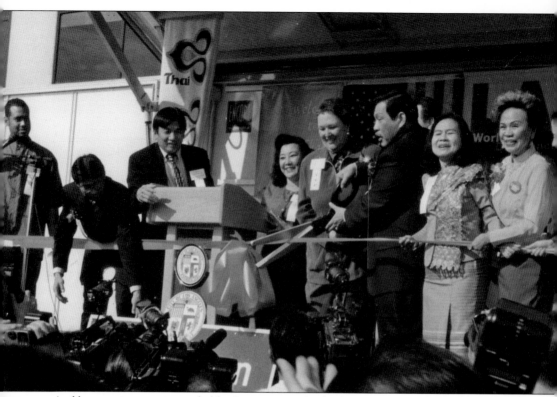

A ribbon-cutting ceremony is held in January 2000 for the designation of Thai Town. Councilwoman Jackie Goldberg, Thai consul general Suphot Dhirakaosal, Thai CDC staff, and the Thai Town Formation Committee members were on hand to cut the ribbon.

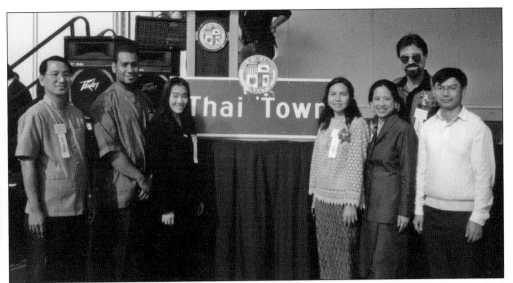

Thai CDC staff is photographed around the Thai Town sign after its designation blessing and ribbon-cutting ceremony in Hollywood in January 2000. Thai Town is currently located in the area surrounding Hollywood Boulevard between Western Avenue and Normandie Avenue in East Hollywood.

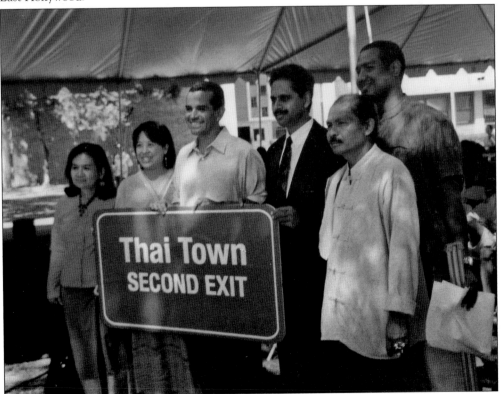

A mock Thai Town freeway sign is held up at the Thai Cultural Day in September 2000, to publicize Thai CDC's victory in obtaining five freeway signs for Thai Town on both sides of the Hollywood 101 Freeway at no charge, with the help of then-assemblyman Antonio Villaraigosa.

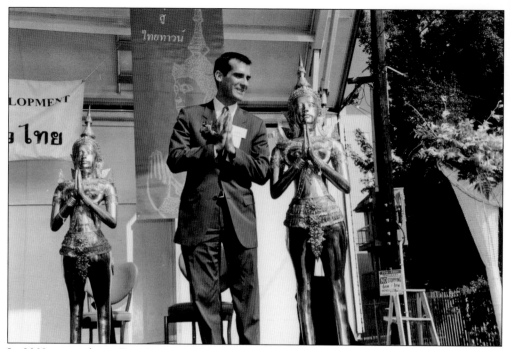

In 2002, councilman Eric Garcetti is posing with the Thai Apsonsi angels and mimics the wai Thai greeting at a ceremony organized by Thai CDC in Thai Town to celebrate their arrival from Thailand. The City of Los Angeles declared it "City of Angels Day."

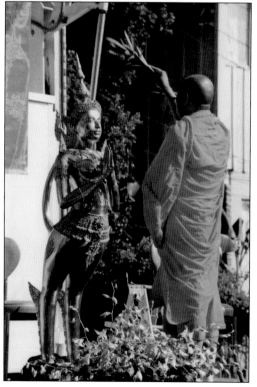

The Thai Apsonsi angels receive a blessing from a Thai monk at the welcome ceremony in Thai Town.

Thai consul general Isinthorn Sornvai, the staff of Thai CDC and Thai Airways International, and members of the Thai Town Formation Committee are at the unveiling of the angels.

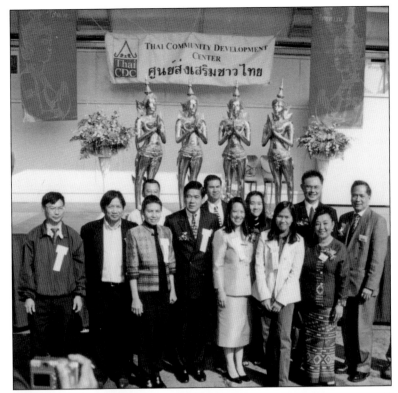

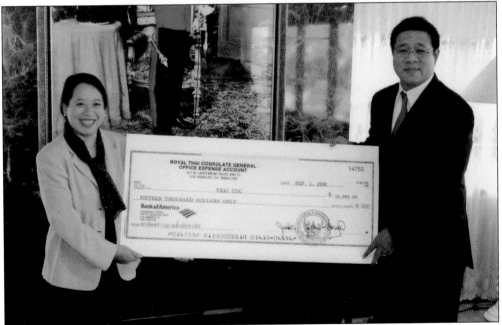

Thai consul general Jukr Boon-Long presents a check to Thai CDC for $15,000 toward the cost of installing one of the Thai Town Angel Apsonsi Gateways. The photograph was taken at the Royal Thai Consulate of Los Angeles in September 2006. The Royal Thai Consulate has always been a strong advocate for Thai CDC and Thai Town.

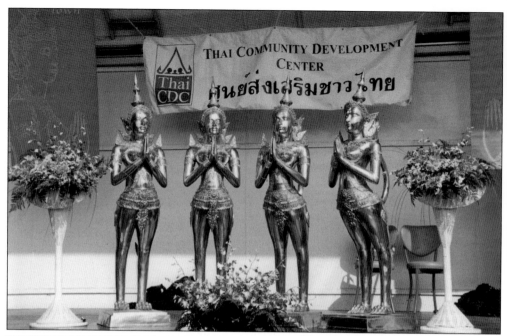

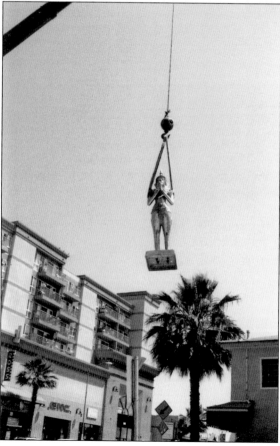

The Thai Town Apsonsi angel was installed onto her pedestal in Thai Town in 2006 after Thai CDC worked for six years to raise sufficient funds for its construction and permits required by the City of Los Angeles. Funding from the City of Los Angeles Public Works Department Community Beautification Grant allowed Thai CDC to commission the making of the statues in Thailand, and Thai Airways International transported all four to Los Angeles at no charge as a match.

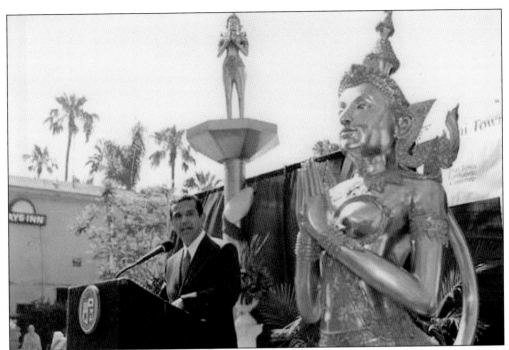

Los Angeles mayor Antonio Villaraigosa is speaking at a historic ceremony that Thai CDC held in 2007 to unveil the Apsonsi angel statue as a part of the Thai Town Gateway project.

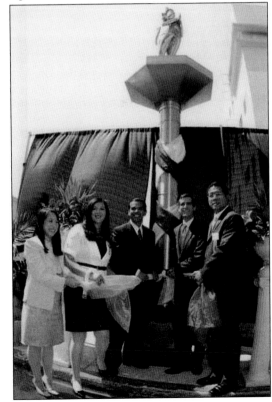

Seven years later, after much fundraising by Thai CDC and a difficult permitting process, the angels were finally installed and a ribbon-cutting ceremony was held in July 2007, with mayor Antonio Villaraigosa, council president Eric Garcetti, Thai consul general Jukr Boon-Long, and Public Works commissioner Cynthia Ruiz.

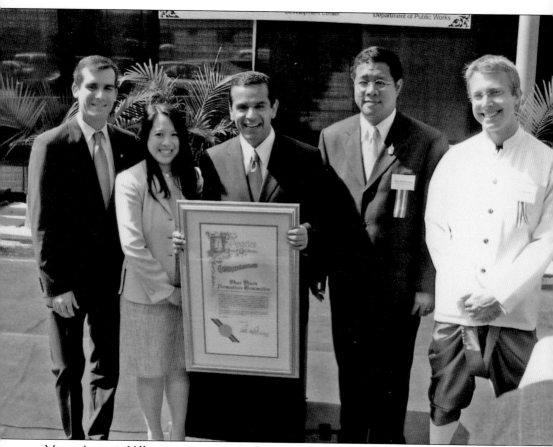

Mayor Antonio Villaraigosa presents the Thai Town Formation Committee with a proclamation from the City of Los Angeles in honor of the gateway unveiling. Council president Eric Garcetti, Thai consul general Jukr Boon-Long, and emcee Todd Hansen are also pictured.

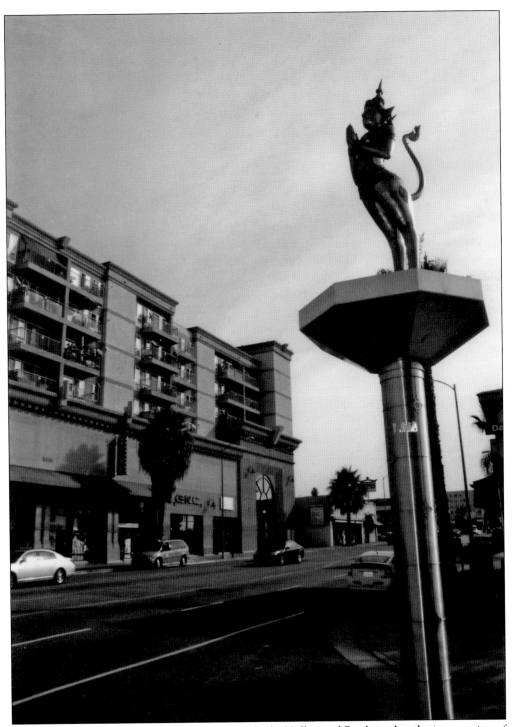

This Thai Angel Apsonsi Gateway Statue overlooks Hollywood Boulevard at the intersection of Western Avenue in Thai Town. Bangkok and Los Angeles are both the "City of Angels" so it is fitting to have an angel welcoming visitors to Thai Town. The Apsonsi is a mythical half-woman, half-lion figure found in the legendary Ramakien tales.

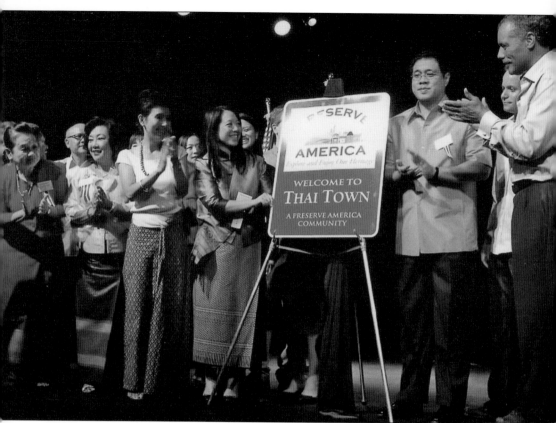

In 2008, Thai CDC successfully obtained the Preserve America Neighborhood designation for Thai Town. The Preserve America road sign for Thai Town was unveiled at the Barnsdall Art Park Gallery Theater in Hollywood at the 16th Annual Thai Cultural Day. Pictured on stage are members of the Thai Town Formation Committee and Preserve America Honorary Committee, Consul General Jukr Boon-Long, Chancee Martorell, a representative from the Community Redevelopment Agency, and councilman Bernard Parks.

Pictured are Thai CDC staff Pheel Wang and Hisano Niikura, and their CDC intern Beatrice "Tippe" Morlan. They are at the 16th Annual Thai Cultural Day held at Barnsdall Art Park in Hollywood in 2008 on the occasion of the designation of Thai Town as a Preserve America Neighborhood by the White House.

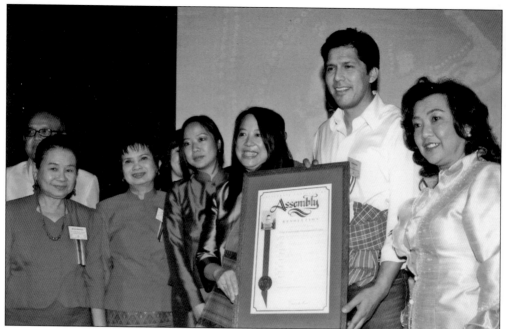

Assemblyman Kevin De Leon presents a proclamation in September 2008 to the Thai CDC and members of the Thai Town Formation and Honorary Preserve America Committees. The Preserve America road sign is being unveiled at a ceremony during the 16th Annual Thai Cultural Day at the Barnsdall Art Park Gallery Theatre in Hollywood.

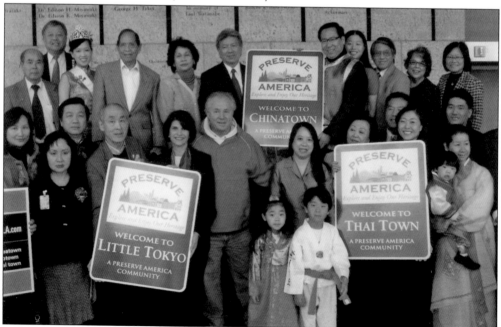

Congresswoman Lucille Roybal Allard and Los Angeles councilman Tom La Bonge are celebrating with the Asian Pacific Islander Preserve America Neighborhood Coalition at the Japanese American National Museum. Preserve America Neighborhood designations were received from the White House for Little Tokyo, Chinatown, and Thai Town in 2008.

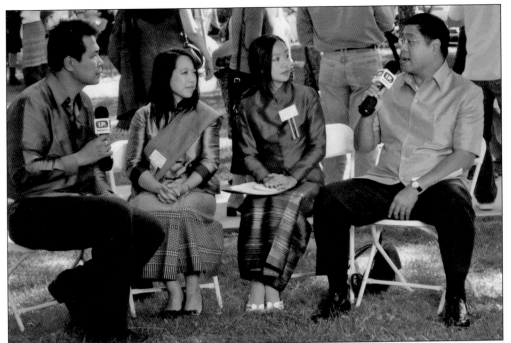

IPTV reporter Panupon Rugtae-Ngam interviewed Teresa Chung, representative of the Thai Community Arts and Cultural Center, Chancee Martorell, and the Hon. Jukr Boon-Long (Thai consul general) during Thai Town's designation as a Preserve America Neighborhood in 2008.

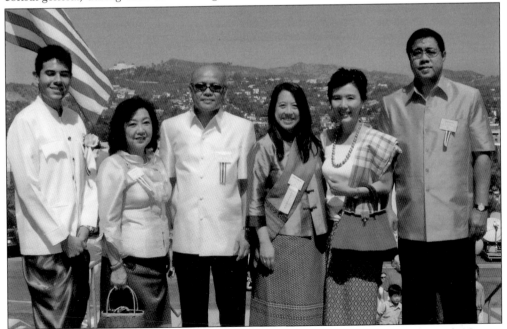

Pictured from left to right are Alex Holsheimer (a Thai CDC community planner), Nittaya Gibson and Prasertchao Thuvanuti (members of the Thai Town Preserve America Honorary Committee), Chancee Martorell, and Thai consul general Jukr Boon-Long and his wife at the 16th Annual Thai Cultural Day in 2008.

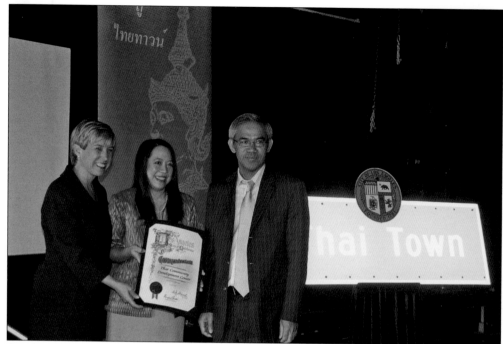

October 27, 2010, marked the 10th anniversary of Thai Town, so a celebration to commemorate the occasion and highlight Thai CDC's accomplishments with respect to fulfilling the vision of Thai Town was held at Thailand Plaza. Dignitaries, representatives of other communities, and members of the Thai community were in attendance and offering their praises. Los Angeles city controller Wendy Gruel presented a certificate in recognition of the 10-year anniversary to Thai CDC executive director Chancee Martorell and Thai consul general Damrong Kraikruan. The second photograph includes Thai CDC staff and interns at the commemoration.

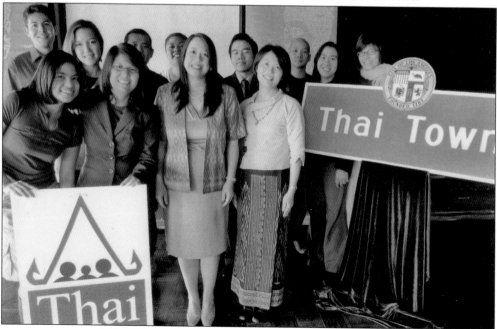

Ten

CIVIC ENGAGEMENT
THE ROAD TO POLITICAL EMPOWERMENT

The campaign to designate Thai Town was truly the first and most exemplary example of civic engagement by the Thai community. The campaign entailed creating a Thai Town Formation Committee by Thai CDC with representatives of the community and training the committee in civics and participatory democracy. Thai CDC trained the committee members in petition collection, postcard mailing, and support letter solicitation. The committee had to canvass the East Hollywood neighborhood to collect over 1,000 pro–Thai Town signatures from local multiethnic residents and business owners and sent over 500 pro–Thai Town postcards to then-councilwoman Jackie Goldberg, whose council district included Thai Town. They also had numerous support letters sent to the councilwoman's office from the broader community, including various non-Thai community organizations.

For Thai CDC, Thai Town's realization has been a form of community and political empowerment, because it has helped establish a Thai identity within the diversity of Los Angeles. It is also an assertion of the Thai community's consciousness and represents a community-building process. By 2010, a decade after its designation in 1999, Thai Town has become an important economic base for the Thai community and cultural destination for Southern California residents.

In 2008, Thai Town received the distinction of being designated a Preserve America Neighborhood by the White House. Thai Town is now on the national map and has access to funding for heritage marketing available from Preserve America.

The road to political empowerment required the Thai community to develop links with local government agencies, elected officials, and private foundations. The Thai CDC has organized and empowered disenfranchised Thais and advocated for their needs since 1994. The process of building strategic external links also goes beyond the neighborhood and has included electoral work and politics. It also involved coalitions and alliances with other ethnic communities to develop collective power.

Such efforts have been particularly relevant for the low-income Thai community, since it is comprised primarily of immigrants with limited electoral participation and few resources. One political empowerment strategy is the effort to see Thais elected into office. Thai American Gorpat Henry Charoen was elected to La Palma City Council in Orange County, and author Chanchanit Martorell was appointed by Los Angeles mayor Antonio Villaraigosa as a planning commissioner for the central area of the Los Angeles Planning Commission.

The Thai Chamber of Commerce sponsored Thai American college students Genevieve Siri, Chancee Martorell (then Hirunpidok), and Tom Kruesopon during their internships with the offices of mayor Tom Bradley, councilman Michael Woo, and state senator Art Torres in 1990.

The Thai Chamber of Commerce internship program helped the Thai community make external linkages with political offices. The interns are at a function here with the Thai Chamber of Commerce to meet with U.S. Sen. Diane Feinstein and councilman Michael Woo, who was running for mayor of Los Angeles in 1990.

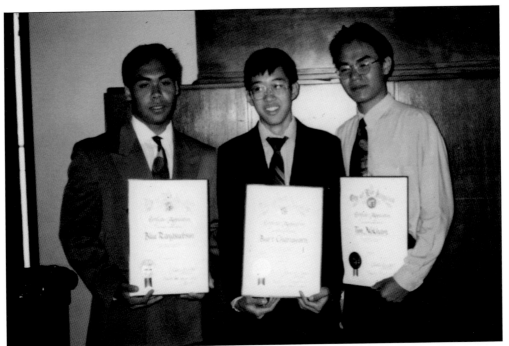

In 1992, Blue Rangsuebsin, Burt Charuworn, and Tim Nokham received certificates of appreciation from the City of Los Angeles for completing their internships. Chancee Martorell trained them to conduct the landmark Thai community needs assessment survey that began the Thai Town designation campaign. Today Blue is a senior financial analyst for Walt Disney Studio Controllership, Tim Nokham is a practicing attorney, and Burt is a physician at UCLA Medical Center.

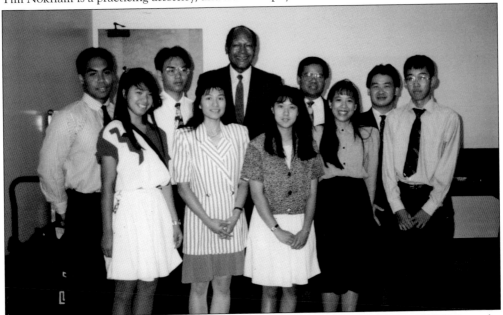

The interns placed in local political offices, members of the Thai Smakom of UCLA, and a representative of the Thai Chamber of Commerce receive a visit from mayor Tom Bradley adding to the further recognition and political voice of the Thai community in 1992.

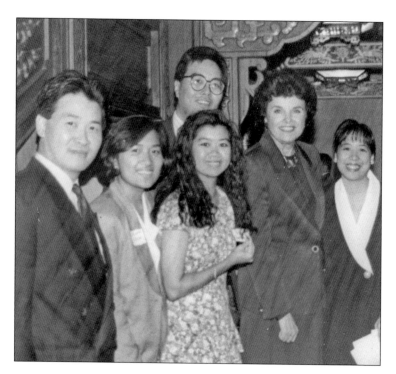

Chancee Martorell and the UCLA Thai Smakom students attend a reception with U.S. Sen. Diane Feinstein in the early 1990s.

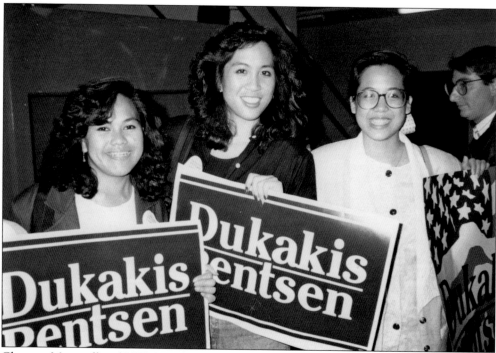

Chancee Martorell and UCLA students are at a campaign rally promoting Michael Dukakis for president. Contributing to greater political clout for the Thai community is the ability to support political campaigns.

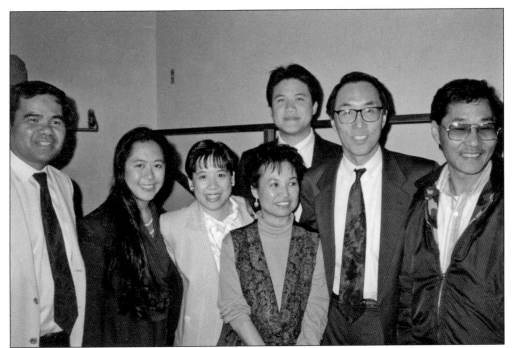

Vivat Sethachuay of the Thai Chamber of Commerce, political interns Genevieve Siri and Chancee Martorell, community organizer San Hongnoi, health educator Nongyao Varanond, and Manote Kongtong meet with councilman Michael Woo in 1991.

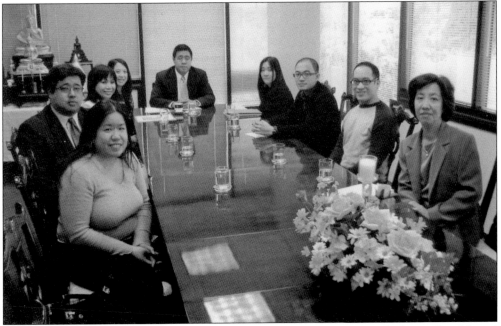

Thai consul general Jukr Boon-Long and his consul, Nantana, meet with the staff and board members of Thai CDC to seek an understanding of and offer assistance on the issues that most concern Thai immigrants in Southern California. His priority while in office was to encourage more civic engagement among Thais in the United States.

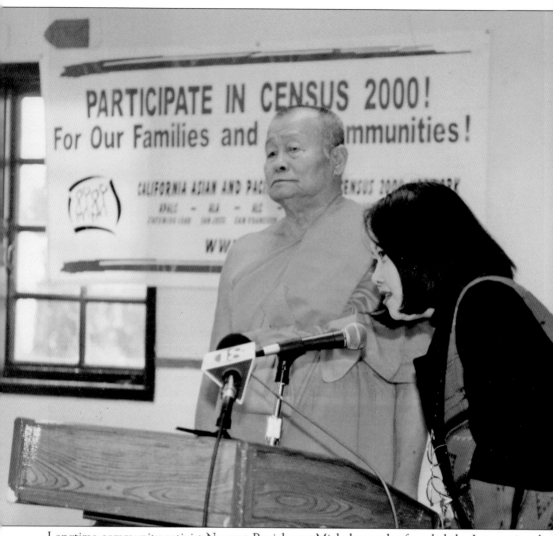

Longtime community activist Nampet Panichpant-Michelson, who founded the International Thai Leadership Council and works as a partnership specialist for the U.S. Census Bureau, spoke at Wat Thai of LA to spread the word about the importance of the census for the empowerment of the Thai community during the 2000 U.S. Census campaign.

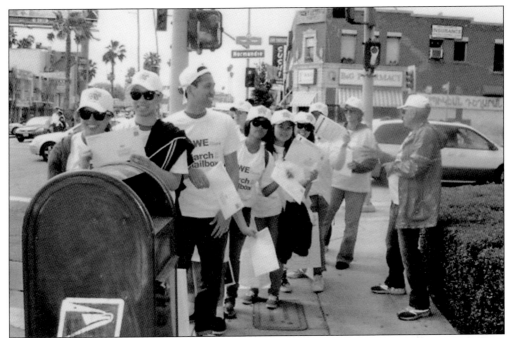

In 2010, many Thai organizations and the Thai media formed the Thai Complete Count Committee (TCCC) to engage in a massive campaign to educate the Thai community about the importance of filling out the census forms and indicating their ethnicity. In April 2010, before the census forms were due, the TCCC organized a "March to the Mailbox" at the annual Thai New Year's Day Songkran Festival with Thai census volunteers bringing the forms to the mailbox. Many young Thai Americans were very eager participants in this movement. (Courtesy of Arisara Aromdee.)

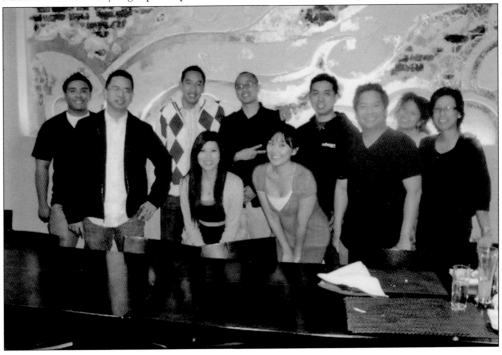

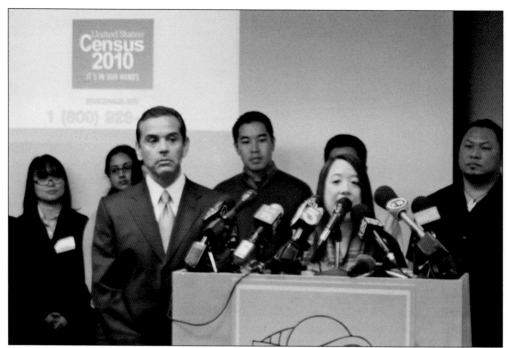

Thai CDC was also part of the Mayor's Complete Count Committee and the Asian Pacific Islander Census Outreach and Education Campaign. A press conference was held to stress the importance of the census in ensuring that communities are counted and empowered.

Members of the Thai American Leadership Delegation visited San Francisco for a Thai community forum over Memorial Day weekend 2010. These young adults traveled to Thailand as ambassadors for the Thai American community. (Courtesy of Arisara Aromdee.)

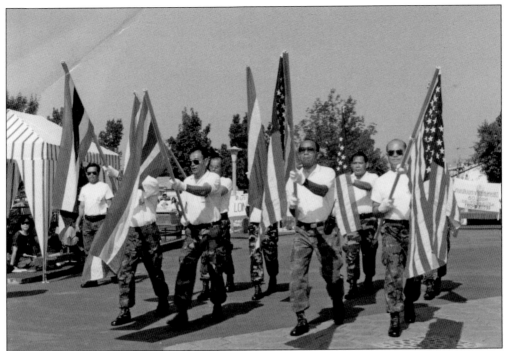

Veterans from various branches of the Thai military are showing their pride as Thais and Americans by holding up both country flags at a Thai parade.

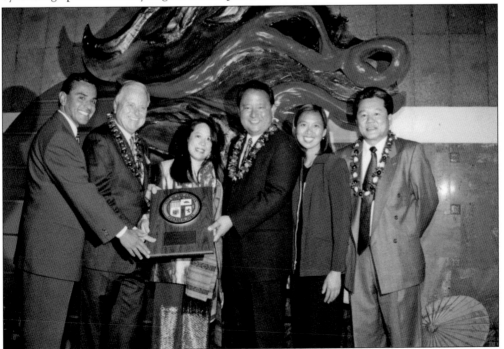

Thai CDC executive director Chancee Martorell receives the Asian Pacific Heritage Month award from Mayor Richard Riordan in May 2000. Assemblyman Antonio Villaraigosa, who became mayor later, is also in the photograph along with Thai CDC board member May Ma.

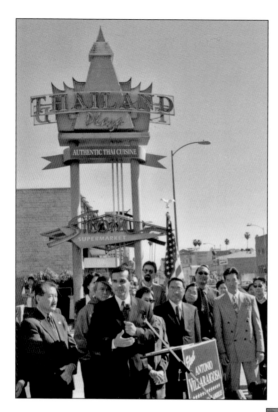

As a candidate for mayor, speaker emeritus Antonio Villaraigosa held his press conference announcing his candidacy in the Asian American community of Thai Town in front of Thailand Plaza in 2001. This was a significant recognition of the Thai community's importance and influence.

Thai CDC executive director Chancee Martorell is with Los Angeles mayor Antonio Villaraigosa at the Thai CDC 11th Anniversary Dinner Fundraiser and Silent Auction held at the Oviatt Penthouse in Downtown Los Angeles in December 2005. The mayor was the keynote speaker that evening.

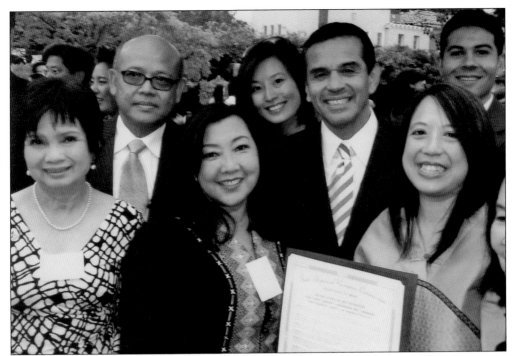

Members of the Thai Town Honorary Preserve America Committee and Thai CDC staff attended the Asian Pacific Islander Leadership reception at the Getty House, the residence of the Los Angeles mayor Antonio Villaraigosa, in Hancock Park in 2009.

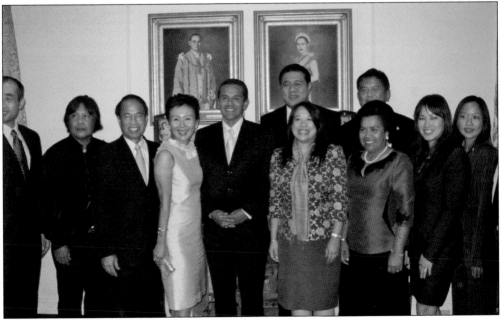

To strengthen relations between the Thai community and their elected officials, Mayor Villaraigosa accepts a dinner invitation with Thai consul general Jukr Boon-Long and Thai community leaders at the residence of the consul general in Hancock Park, which is right across the street from the mayor's residence. The photograph was taken in 2009.

Thais are beginning to realize the importance of civic engagement and are interacting with their local elected officials more, as these photographs show. Above, Thai CDC board member Tina Vacharkulksemsuk and her family are with council president Eric Garcetti. Below, former Thai Town Formation Committee member Nittaya Gibson is with Mayor Villaraigosa.

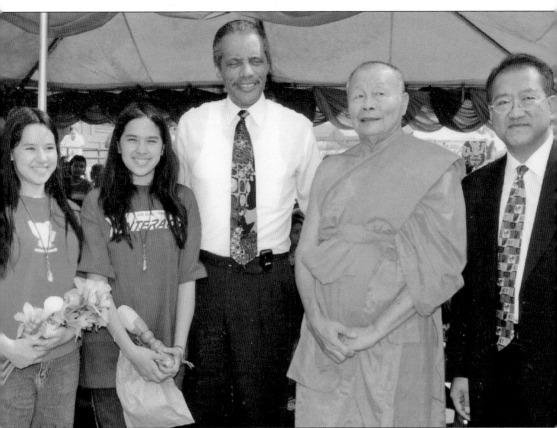

Over the years, the Wat Thai of LA has become a campaign stump for candidates running for office and interested in reaching out to voters. Councilman Bernard Parks is meeting with members of the Thai temple and with the royal Thai princesses, daughters of the eldest princess who used to live in San Diego.

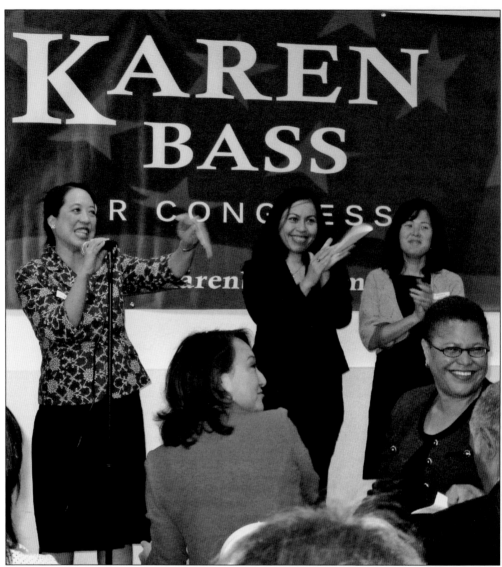

The road to political empowerment for the Thai community also includes supporting candidates who can advocate for issues most pressing to the community. Chancee Martorell is seen here campaigning for Karen Bass for congress in April 2010. Bass won the seat. It is hoped that she will fight in D.C. for underserved communities like the Thai community since her district also includes Thai Town.

A conversation between Thai CDC executive director Chancee Martorell and Hollywood Rotary Club president Ferris Wehbe led to the idea of creating a Thai Town Rotary Club in an effort to develop a service organization for Thai Town. The Thai Town Rotary Club was founded on June 29, 2007, providing more opportunities for civic engagement in the Thai community.

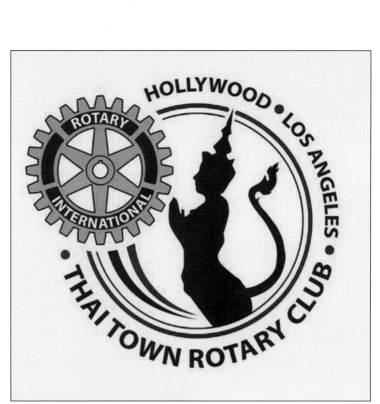

For the first time, in an effort to recruit a diverse group of officers, the LAPD published and widely disseminated in the Thai community this ad, which featured Thai LAPD officer Sgt. Pete Phermsangngam, who has been on the force for over two decades and currently trains the LAPD in tactical strategies.

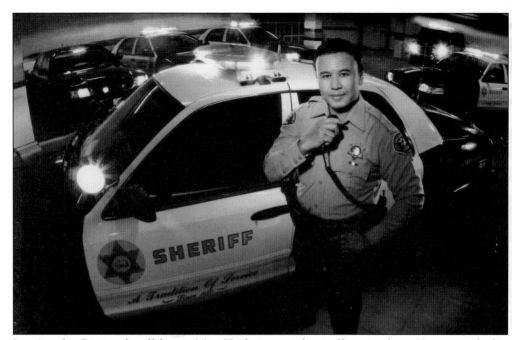

Los Angeles County sheriff deputy Matt Kochaon is in front of his patrol car. He is one of a few Thais in the sheriff department and was the first to be awarded the Medal of Valor, in 2010. (Courtesy of Jump Photography.)

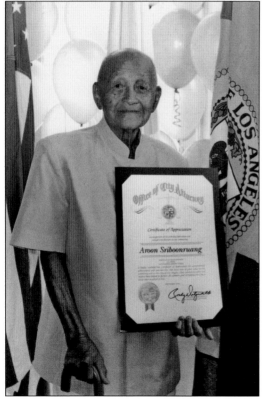

At last, Pa Aroon was recognized by the City of Los Angeles as one of the Pearls of Los Angeles for his many contributions to the social, economic, and cultural fiber of the city at a ceremony held at the historic Pico House in Downtown Los Angeles in 2009.

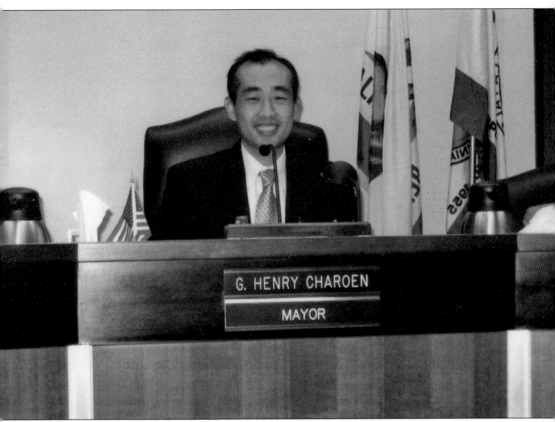

On November 7, 2006, Gorpat Henry Charoen became the first U.S. elected official of Thai descent. He was elected to the La Palma City Council in Orange County, California, and on December 18, 2007, was appointed as mayor for a one-year term, making him the first mayor of Thai descent in the United States. He received his masters of business administration degree from UC Irvine and his bachelor of science degree in Industrial Engineering from USC. Since then, Charles Djou has become the first elected congressman of Thai descent as a member of the House of Representatives for the State of Hawaii. Djou is proudly half Thai and half Chinese, and he also attended USC Law School.

Thai CDC executive director Chancee Martorell was confirmed for her reappointment to the Los Angeles Central Area Planning Commission for another five years upon the request of Mayor Antonio Villaraigosa and sworn into office by council president Eric Garcetti on August 4, 2010.

In an amazing show of unity and strength, members of the Thai community came together to support Chancee Martorell's confirmation at Los Angeles City Hall. The "baseball" handshake with council president Eric Garcetti and councilmember Tom La Bonge truly signifies the emerging clout of the Thai community.

BIBLIOGRAPHY

Lai, Eric, and Dennis Arguelles, ed. *The New Face of Asian Pacific America: Numbers, Diversity and Change in the 21st Century.* San Francisco, CA: AsianWeek, 2003.

Liebhold, Peter, and Harry R. Rubenstein. *Between a Rock and a Hard Place: A History of American Sweatshops, 1820–Present.* Los Angeles, CA: UCLA Asian American Studies Center and Simon Wiesenthal Center Museum of Tolerance in cooperation with the National Museum of American History, Smithsonian Institution, 1999.

Lopez-Garza, Marta, and David R. Diaz, ed. *Asian and Latino Immigrants in a Restructuring Economy: The Metamorphosis of Southern California.* Palo Alto, CA: Stanford University Press, 2001.

Louie, Miriam Ching. *Sweatshop Warriors: Immigrant Women Workers Take on the Global Factory.* Cambridge, MA: South End Press, 2001.

Ong, Paul, ed. *Beyond Asian American Poverty: Community Economic Development Polices and Strategies.* Los Angeles, CA: LEAP Asian Pacific American Public Policy Institute, 1993.

Wong, Kent, and Julie Monroe, ed. *Sweatshop Slaves: Asian Americans in the Garment Industry.* Los Angeles, CA: UCLA Center for Labor Research and Education, 2006.

www.arcadiapublishing.com

Discover books about the town where you grew up, the cities where your friends and families live, the town where your parents met, or even that retirement spot you've been dreaming about. Our Web site provides history lovers with exclusive deals, advanced notification about new titles, e-mail alerts of author events, and much more.

Arcadia Publishing, the leading local history publisher in the United States, is committed to making history accessible and meaningful through publishing books that celebrate and preserve the heritage of America's people and places. Consistent with our mission to preserve history on a local level, this book was printed in South Carolina on American-made paper and manufactured entirely in the United States.

This book carries the accredited Forest Stewardship Council (FSC) label and is printed on 100 percent FSC-certified paper. Products carrying the FSC label are independently certified to assure consumers that they come from forests that are managed to meet the social, economic, and ecological needs of present and future generations.

Find Your Place in History.